Gotic Tattoo Design Book

Gothic tattoo is a style that has evolved from its roots in the gothic subculture of the 1980s, influenced by music, fashion and a dark aesthetic. This style is characterized by its connection with macabre elements, the supernatural and beauty in the dark, reflecting a fascination with death and the occult.

Origins and Influences

Gothic tattoos emerged from the gothic subculture, which developed against a backdrop of melancholic music and gloomy aesthetics. Designs often include religious iconography, such as inverted crosses and rosaries, as well as symbols associated with the occult. Iconic figures such as Siouxsie Sioux and Robert Smith, leaders of bands such as Siouxsie and the Banshees and The Cure, respectively, played an important role in popularizing this aesthetic.

Style Features

Gothic tattoos are distinguished by their use of black and the play of light and shadow, evoking the architectural style of Gothic cathedrals. Designs can include elements such as:

Characters and creatures: Victorian women, vampires, angels, crows and dragons.

Symbols: Skulls, crosses, runes and other esoteric signs.

The outlines in these tattoos are usually less pronounced, and the inscriptions are made with Gothic fonts that feature broken lines and ornaments.

Symbology

The symbolism behind Gothic tattoos is rich and varied. For example:
Gargoyles: They represent Gothic art and were used in medieval architecture.
Skulls: They symbolize bravery and the cycle of life and death.
The Grim Reaper: Represents death, often visualized as a hooded figure with a scythe.
Each tattoo can have a personal meaning, allowing wearers to express their thoughts and feelings through this form of body art.
The Ankh, also known as the "key of life", is a symbol of Egyptian origin that has a deep and varied meaning, especially in the context of Gothic tattoos.

Ankh Symbolism

Eternal Life: The Ankh is primarily a symbol of life and immortality. In Egyptian iconography, gods were depicted holding the Ankh, symbolizing the giving of the breath of life to mortals, making it an emblem of existence beyond death.
Transcendence and Protection: In addition to its connection with life, the Ankh also symbolizes spiritual transcendence and protection. It is believed to carry with it the energy of wisdom and protection against negative forces, making it attractive to those seeking deeper meaning in their tattoos.
Union of the Masculine and the Feminine: The design of the Ankh, which combines a cross with a bow on top, is often interpreted as a symbol of the union of the masculine and the feminine. This duality resonates with the concept of life, since procreation requires both elements.
Gothic Aesthetic: In the context of Gothic tattoos, the Ankh integrates well with other dark and mystical symbols, complementing the overall aesthetic that seeks to explore themes of death, spirituality and the occult. Its distinctive design and rich history make it a popular choice within this style.
The Ankh, therefore, is not only a symbol of life, but also encapsulates concepts of protection, duality and transcendence, making it especially significant for those who choose this design in the Gothic context.

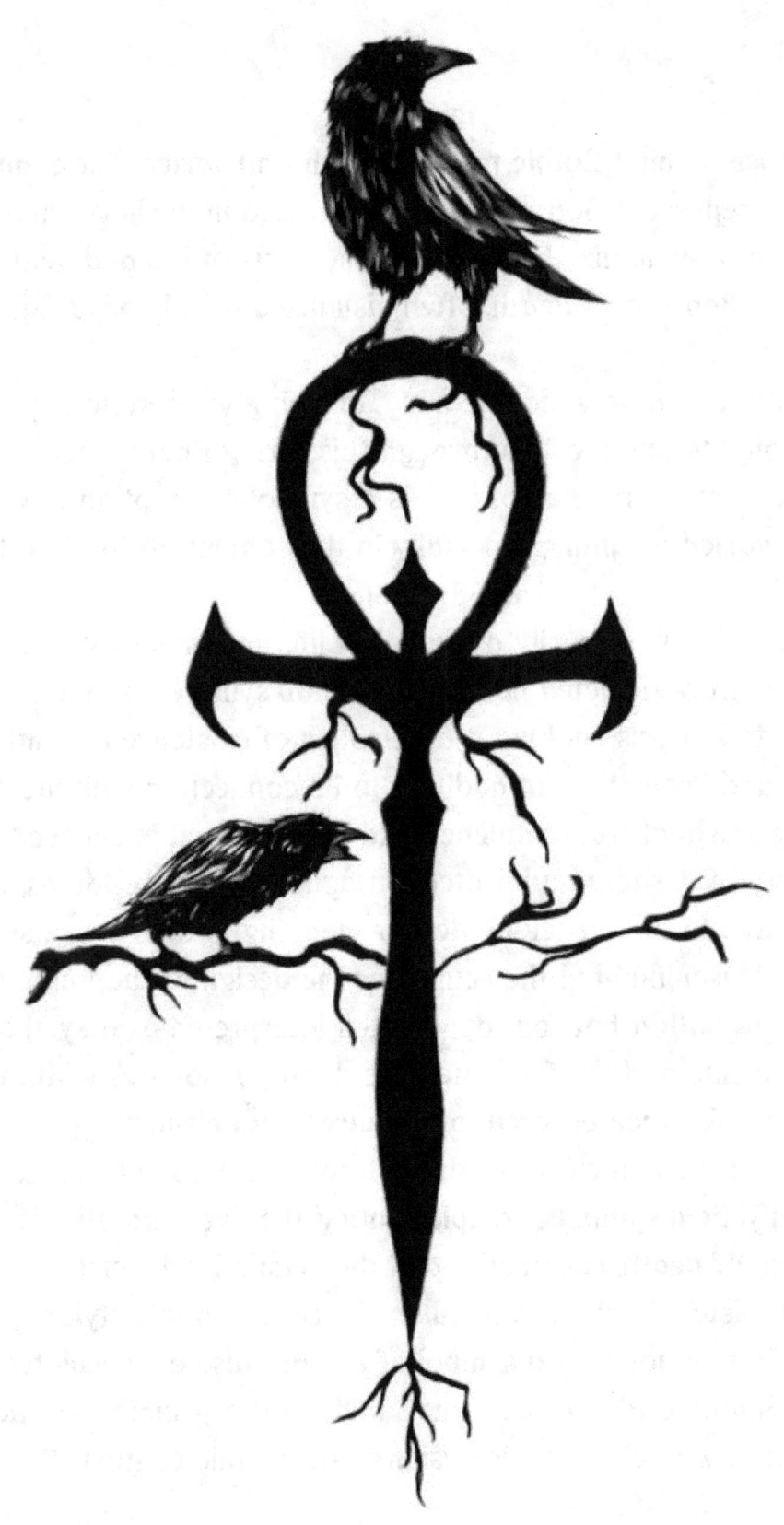

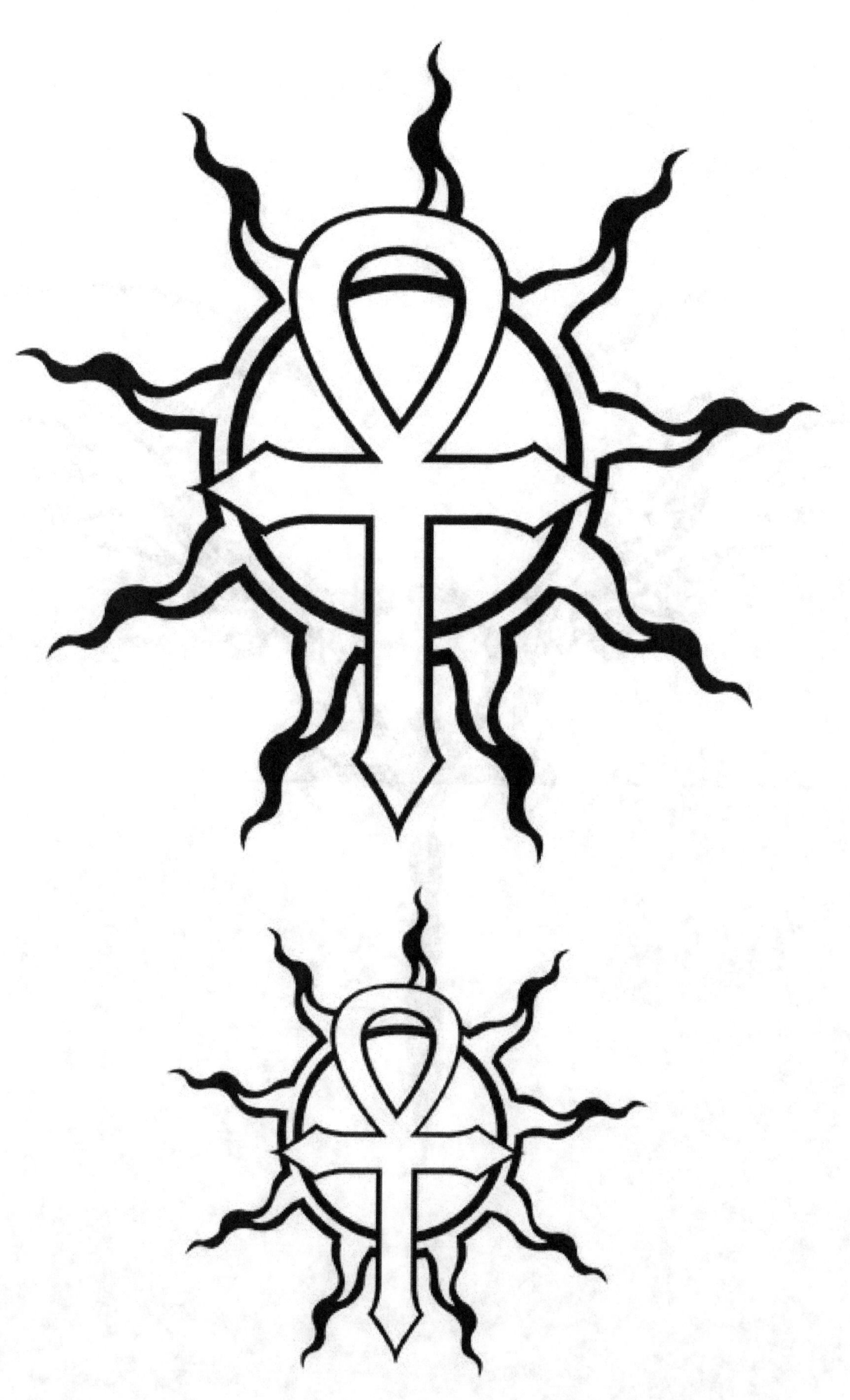

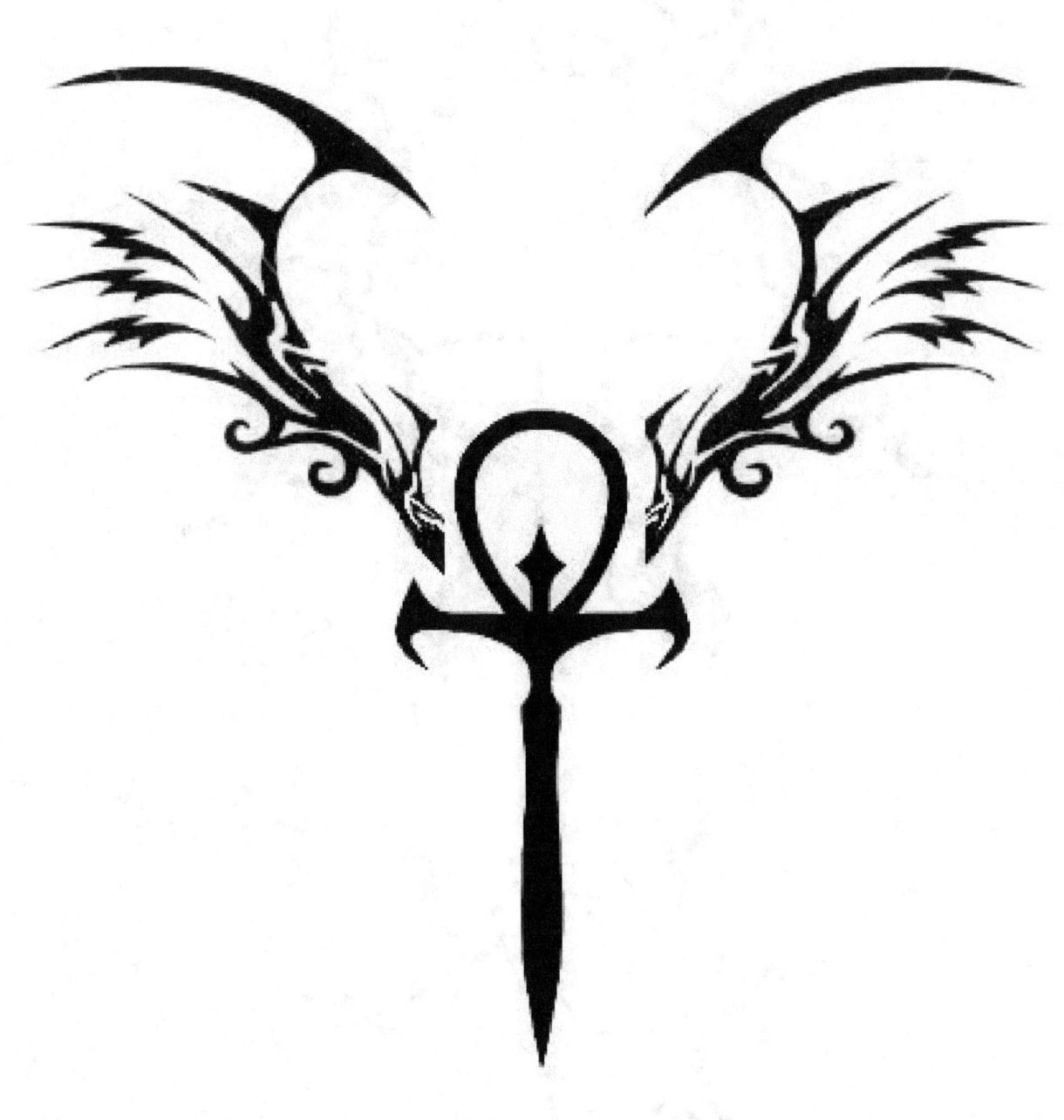

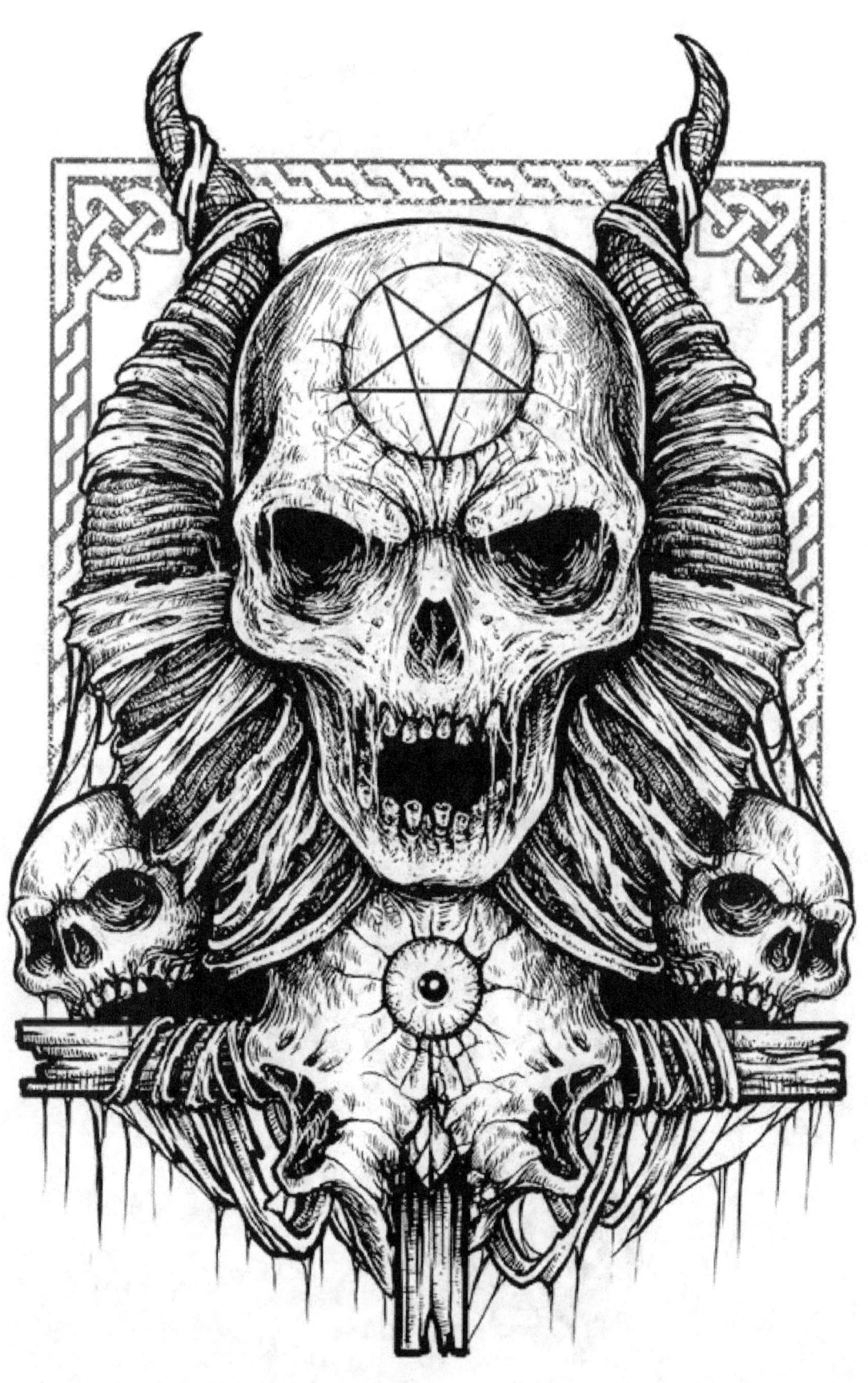

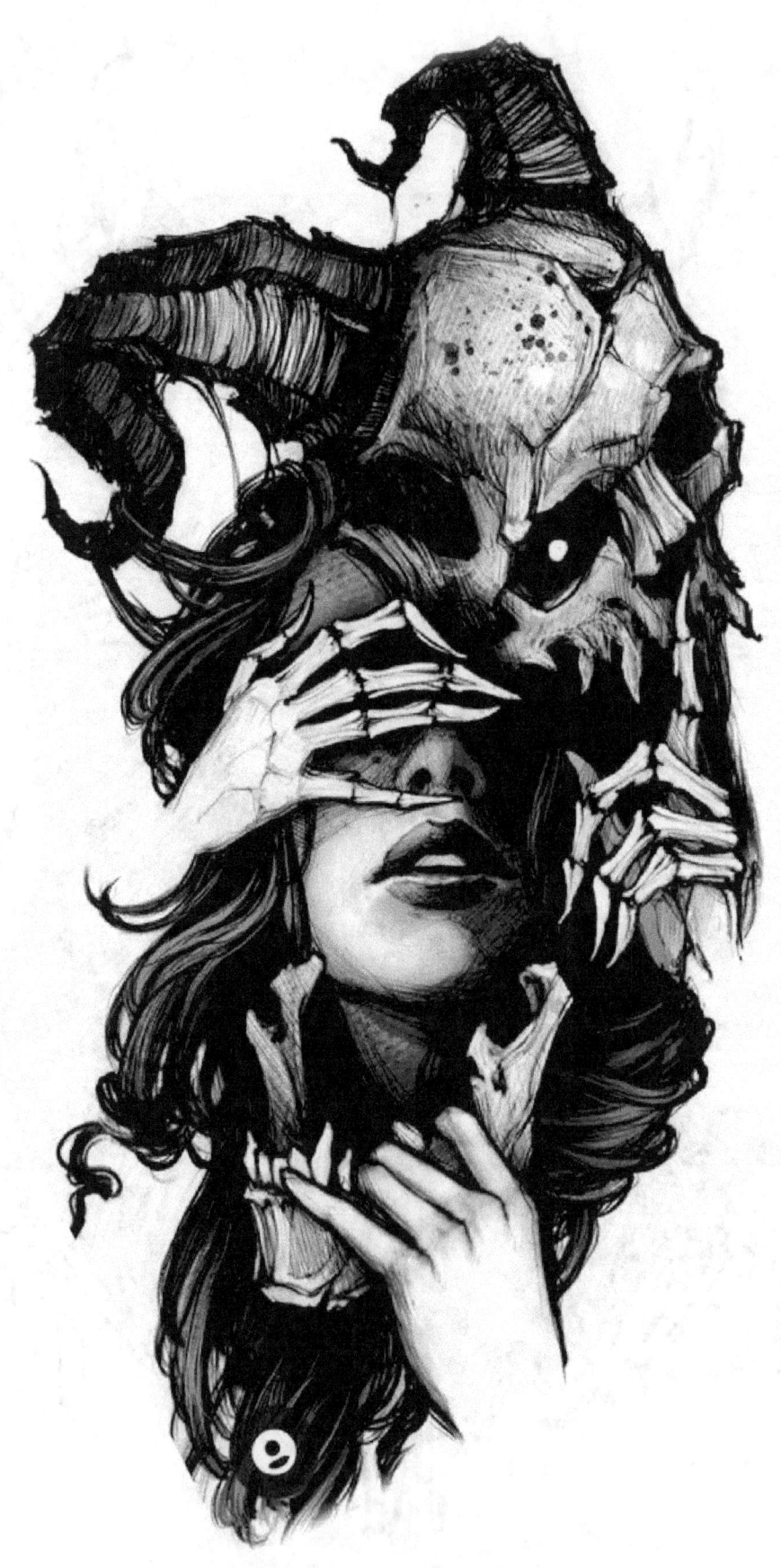

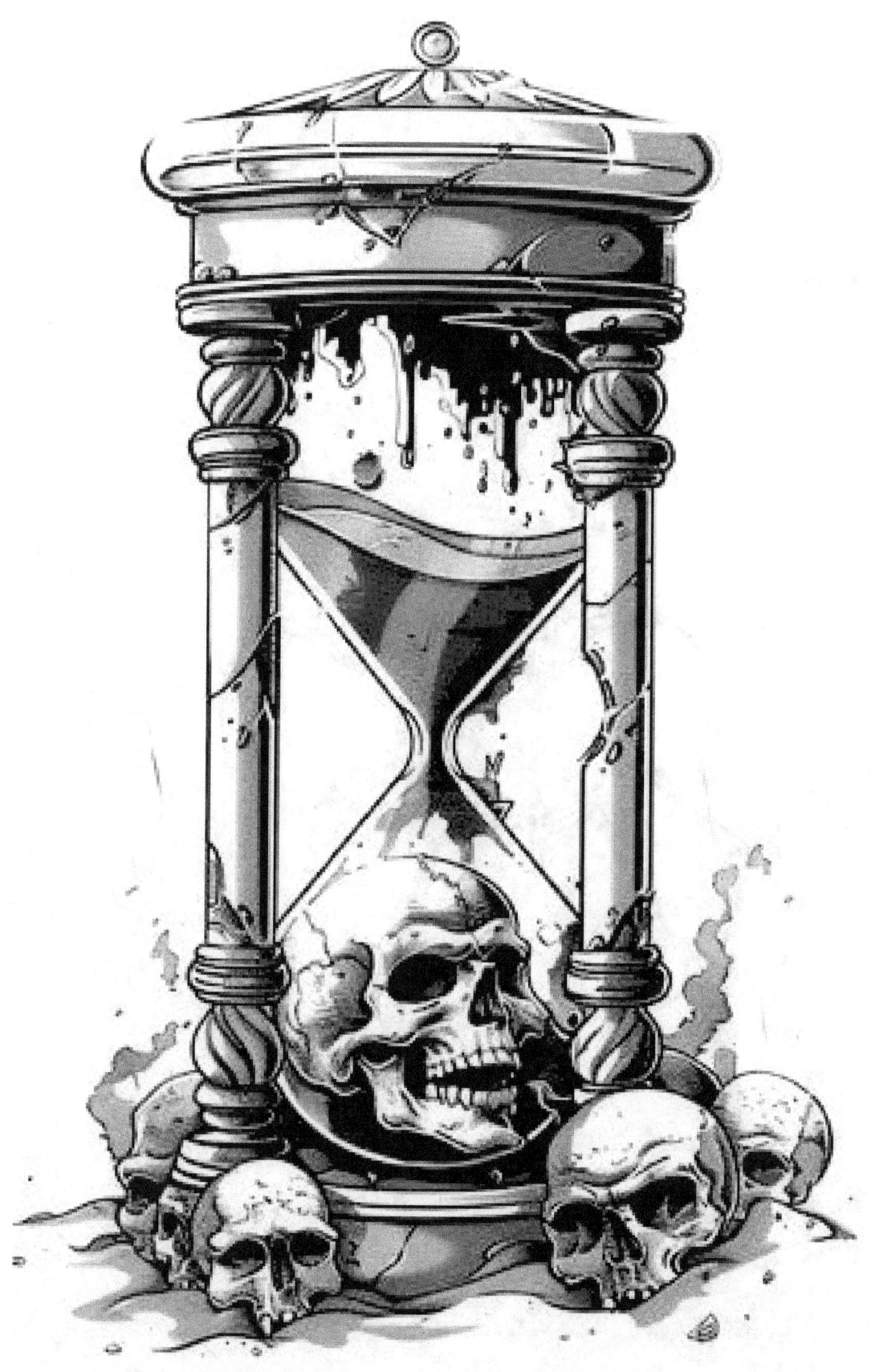

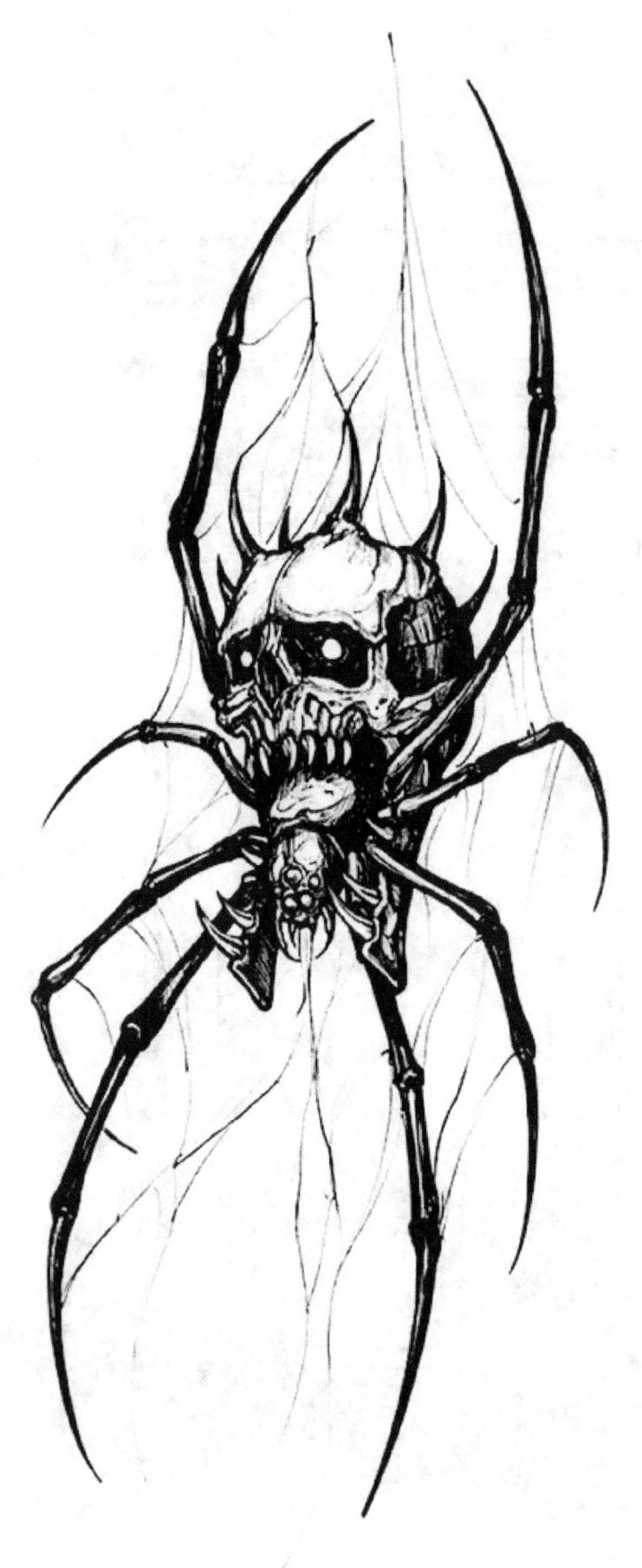

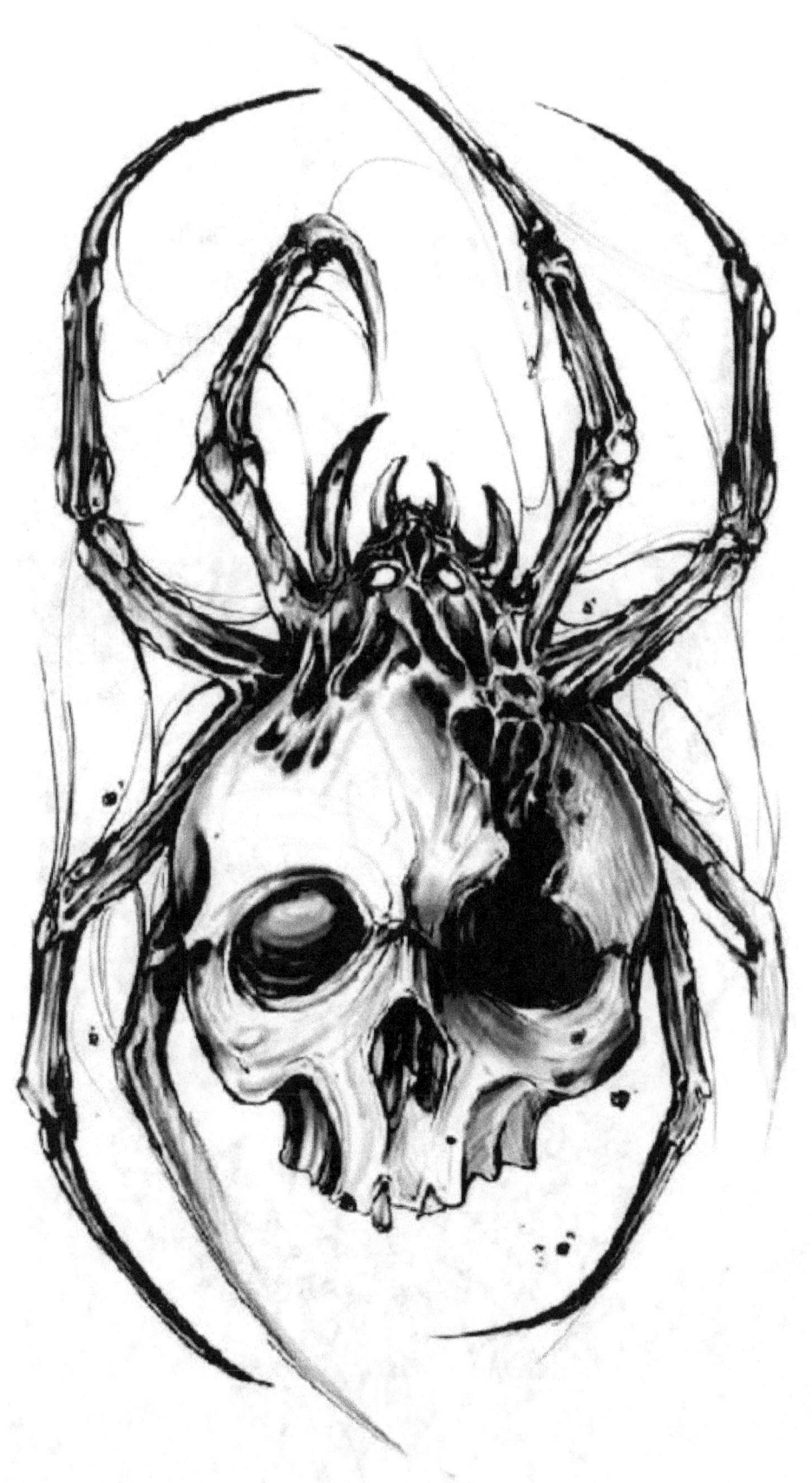

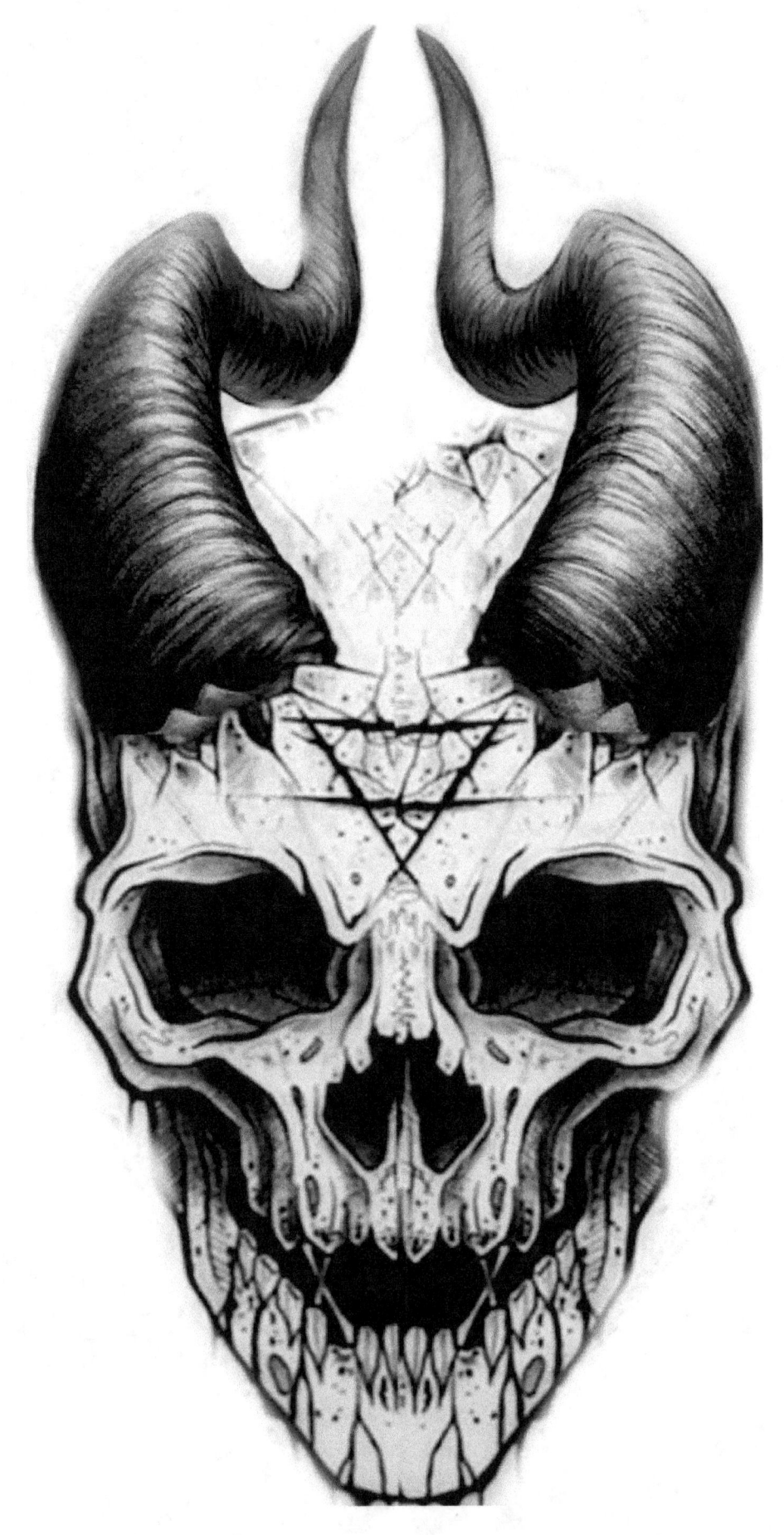

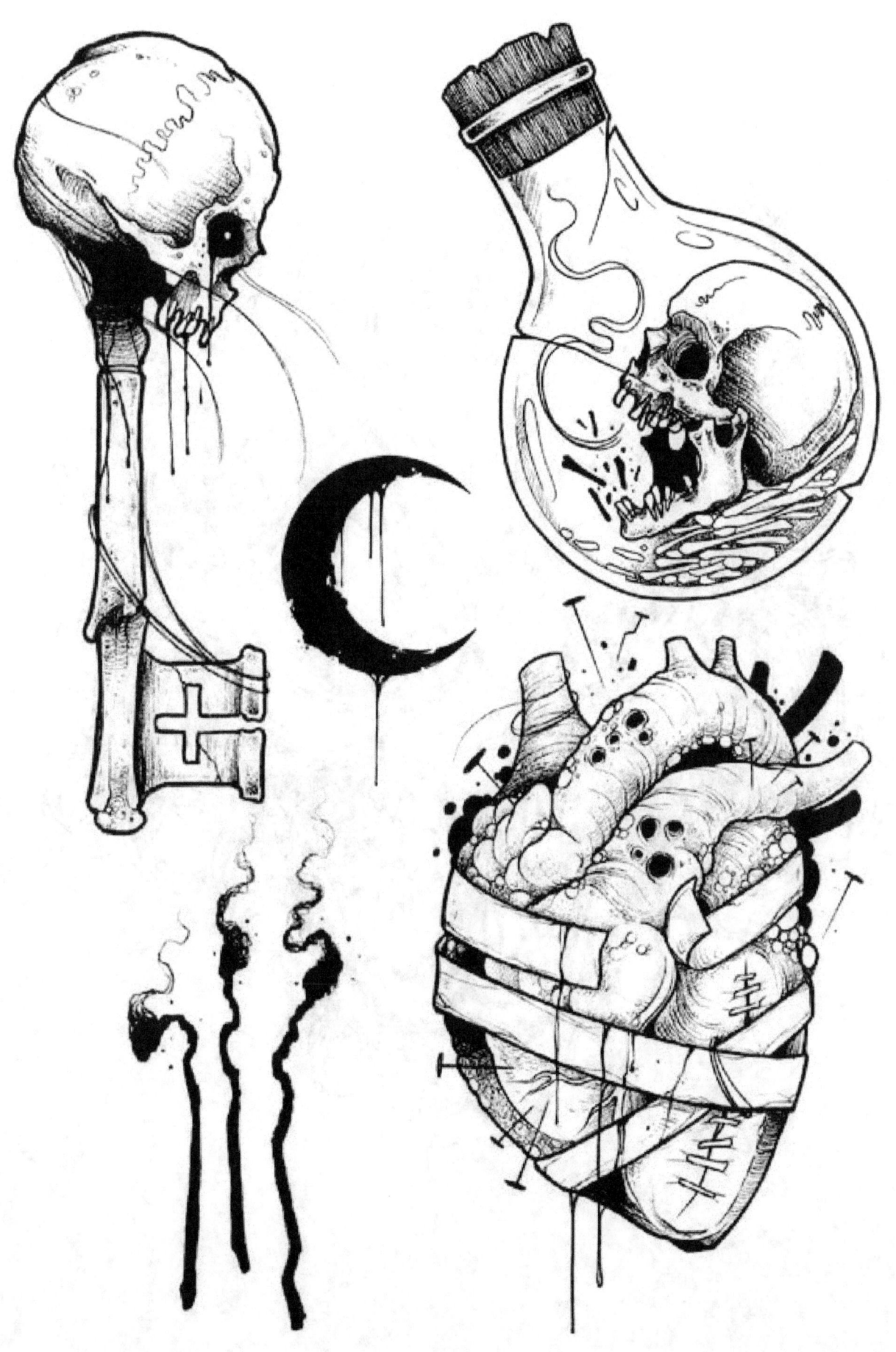

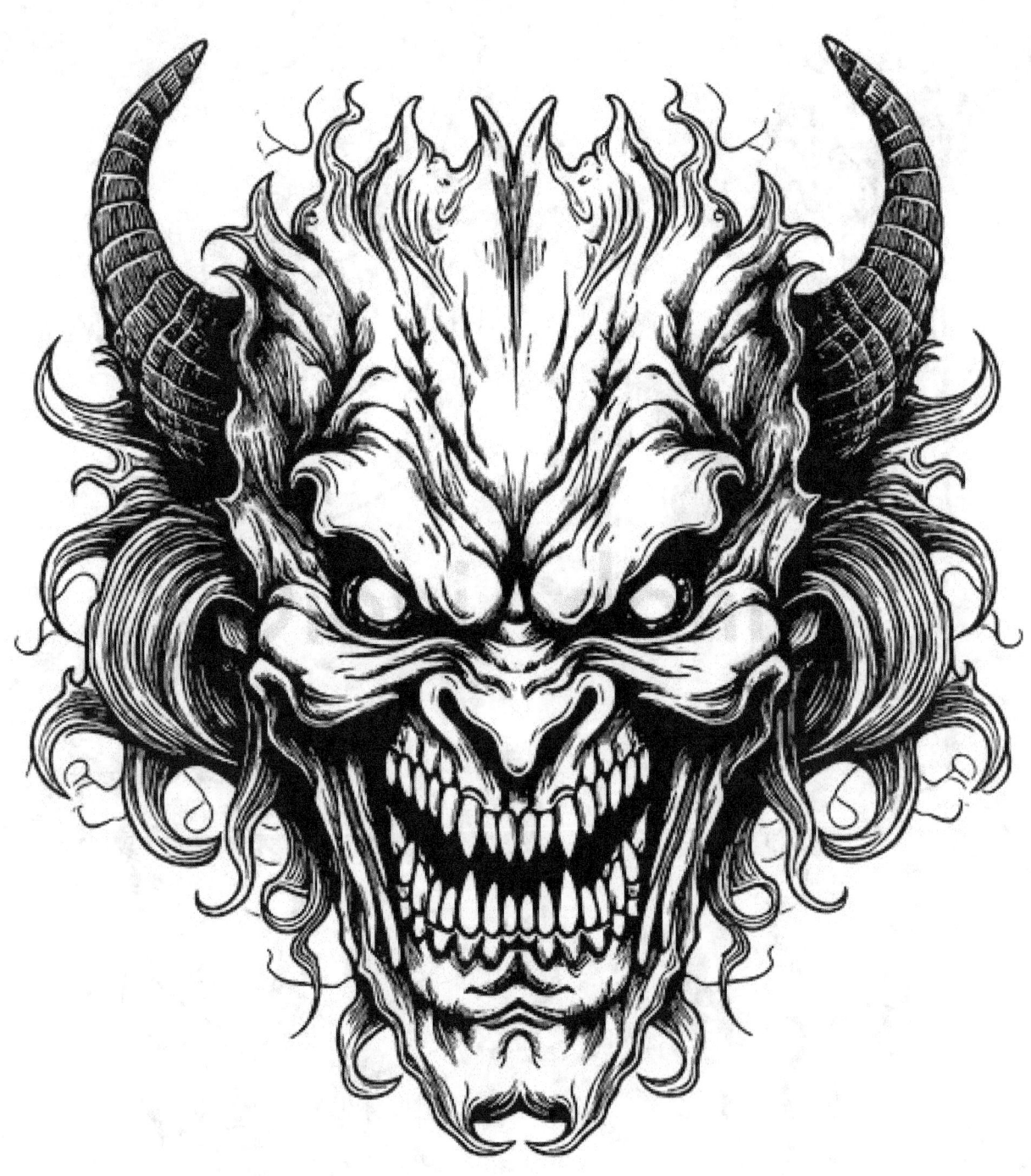

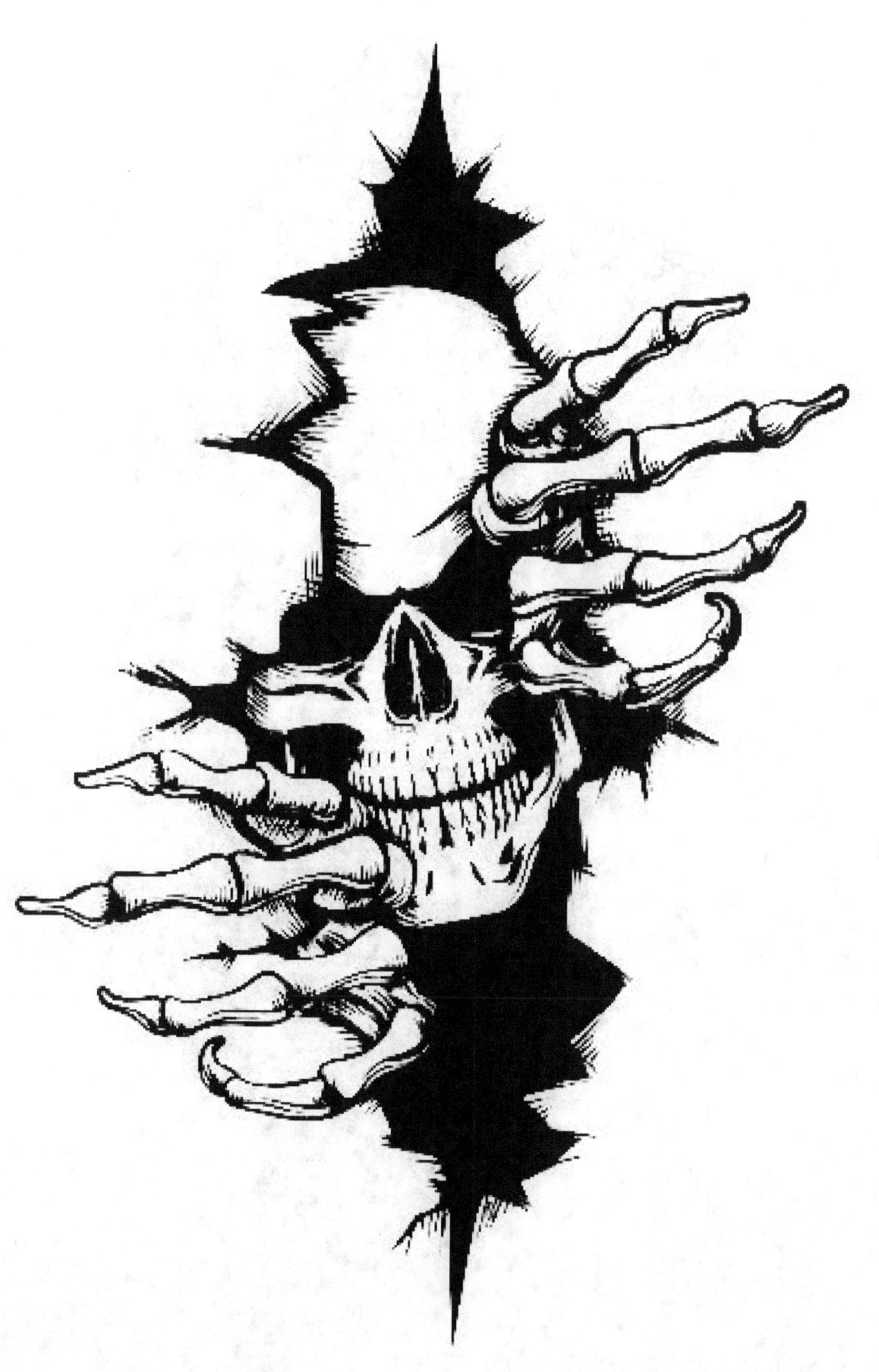

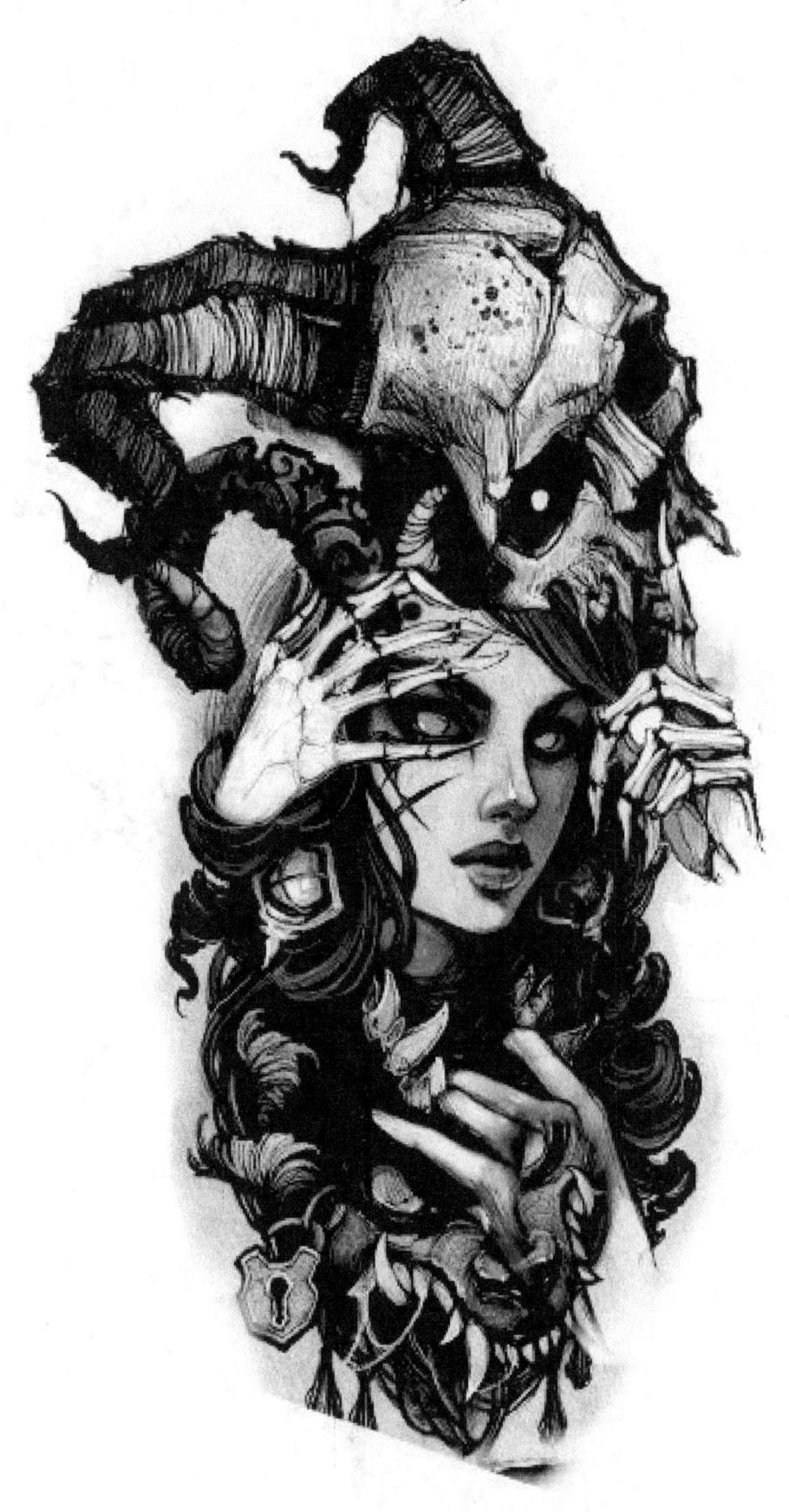

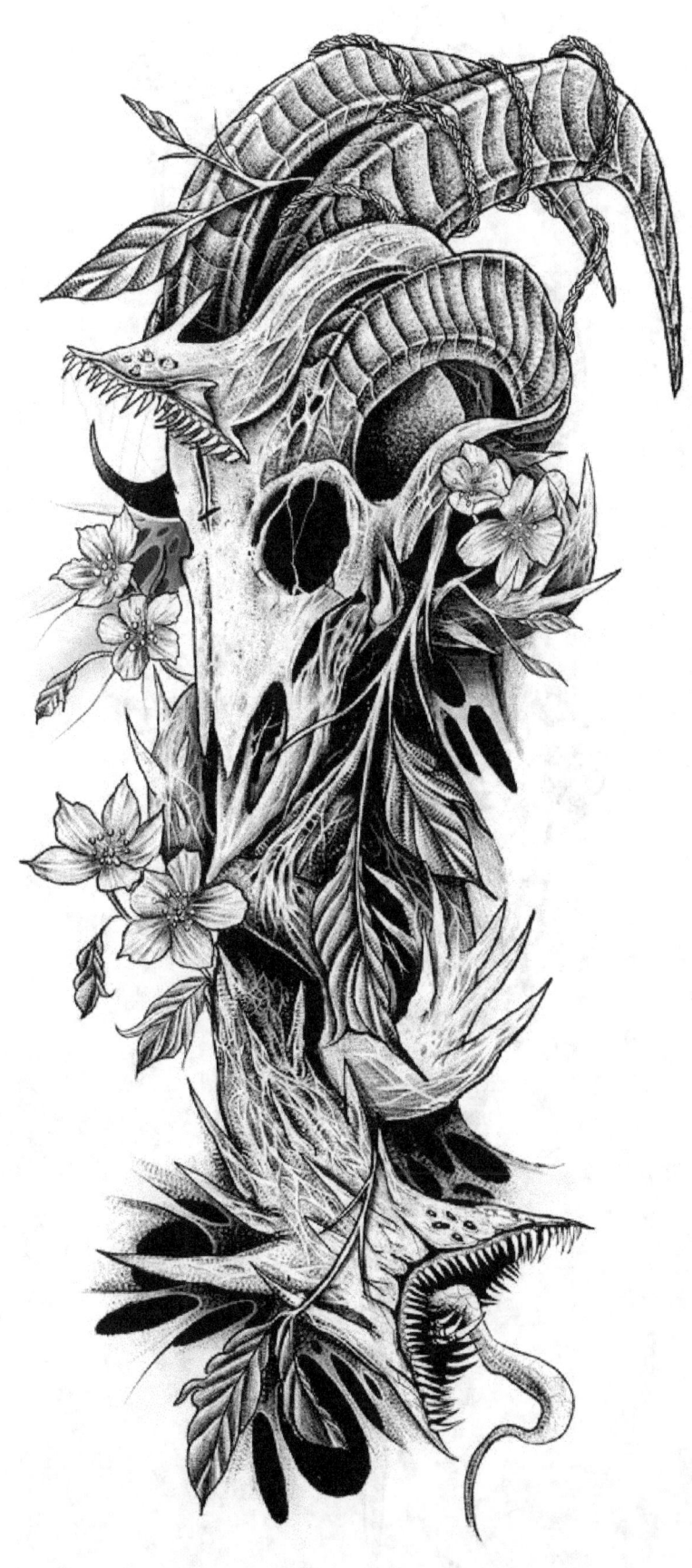

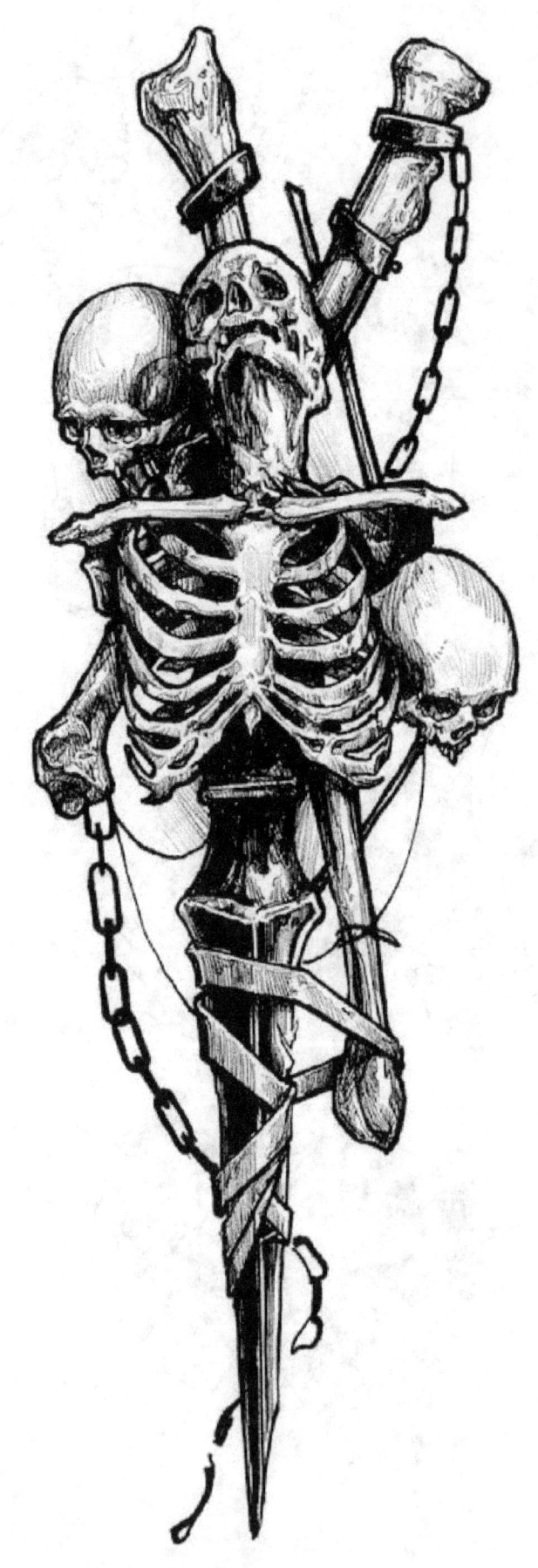

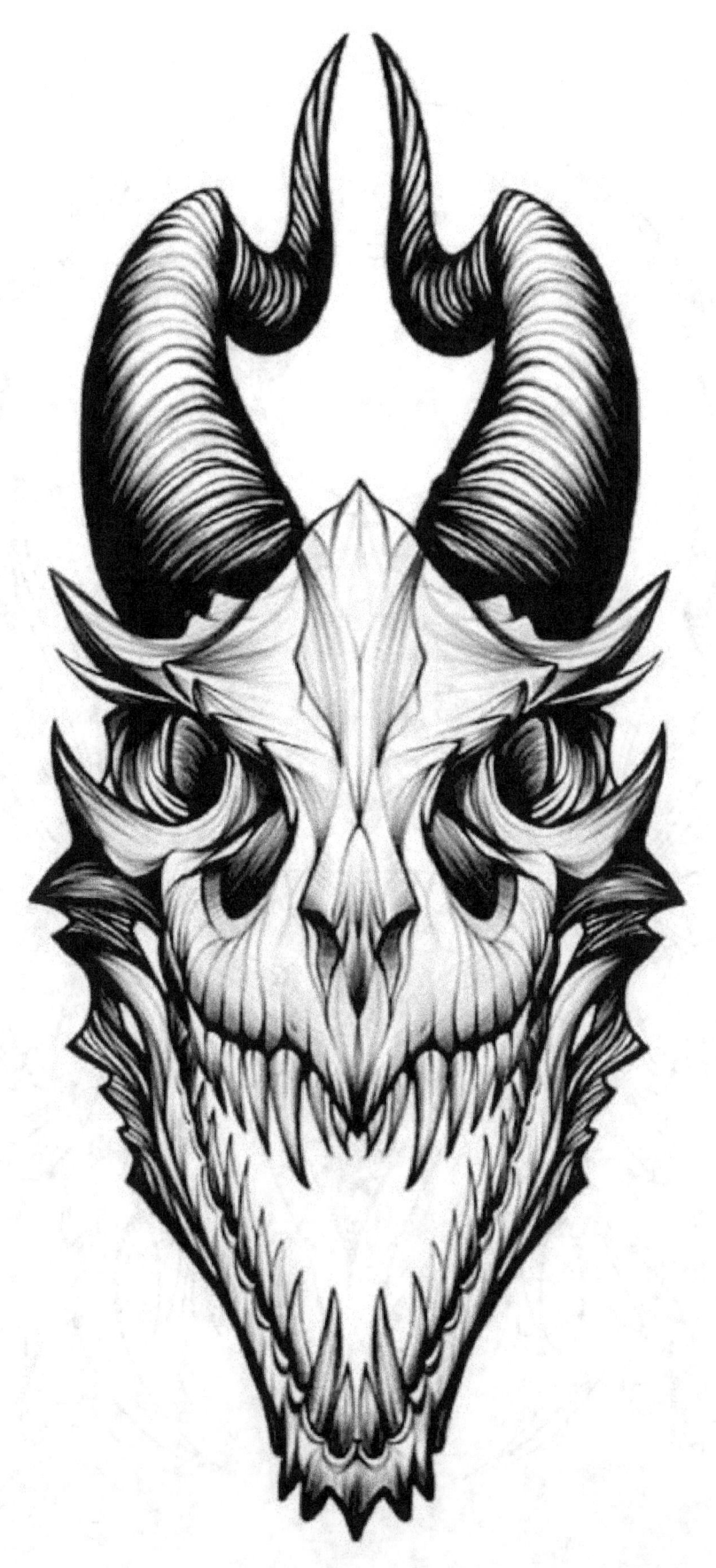

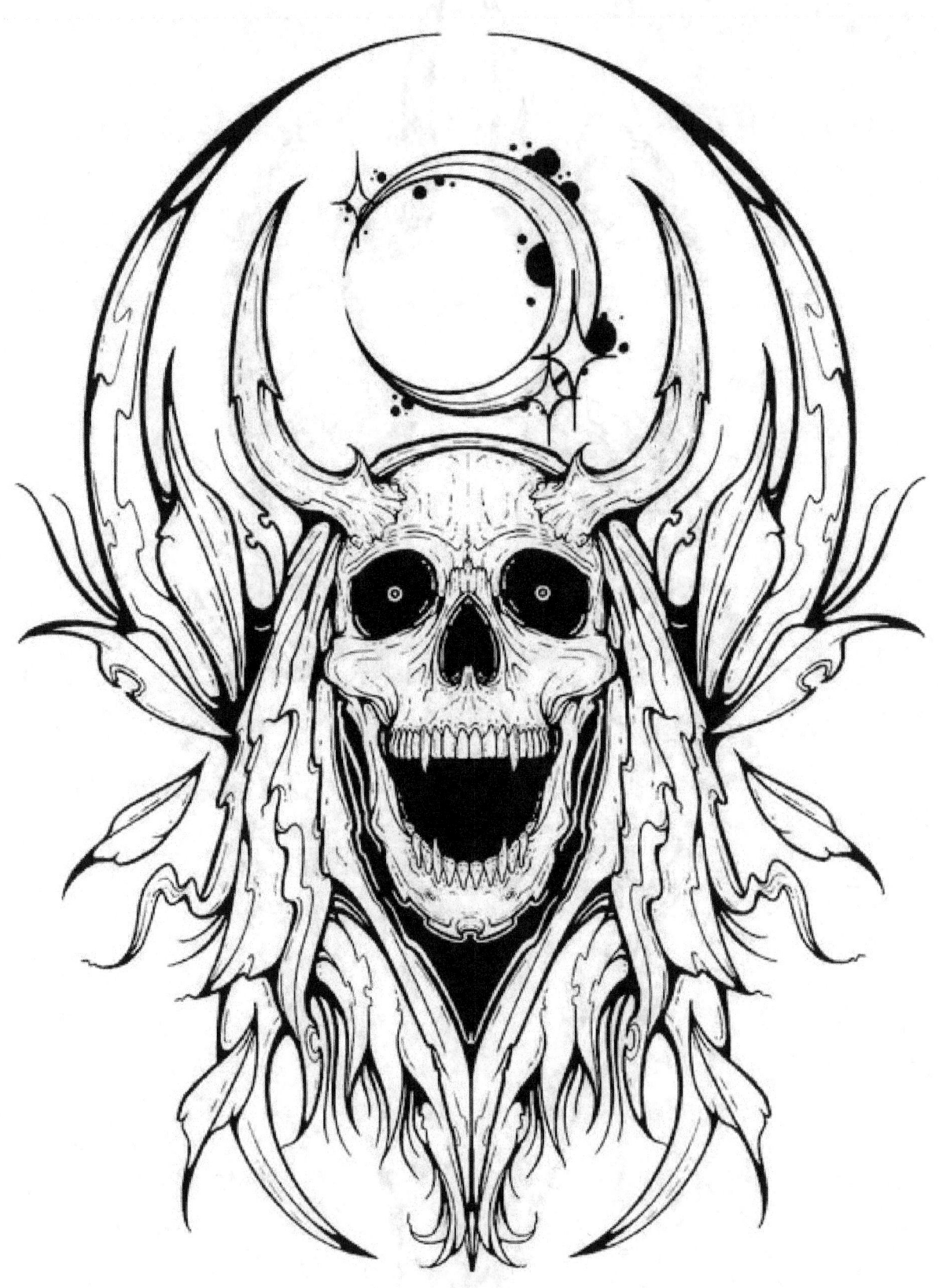

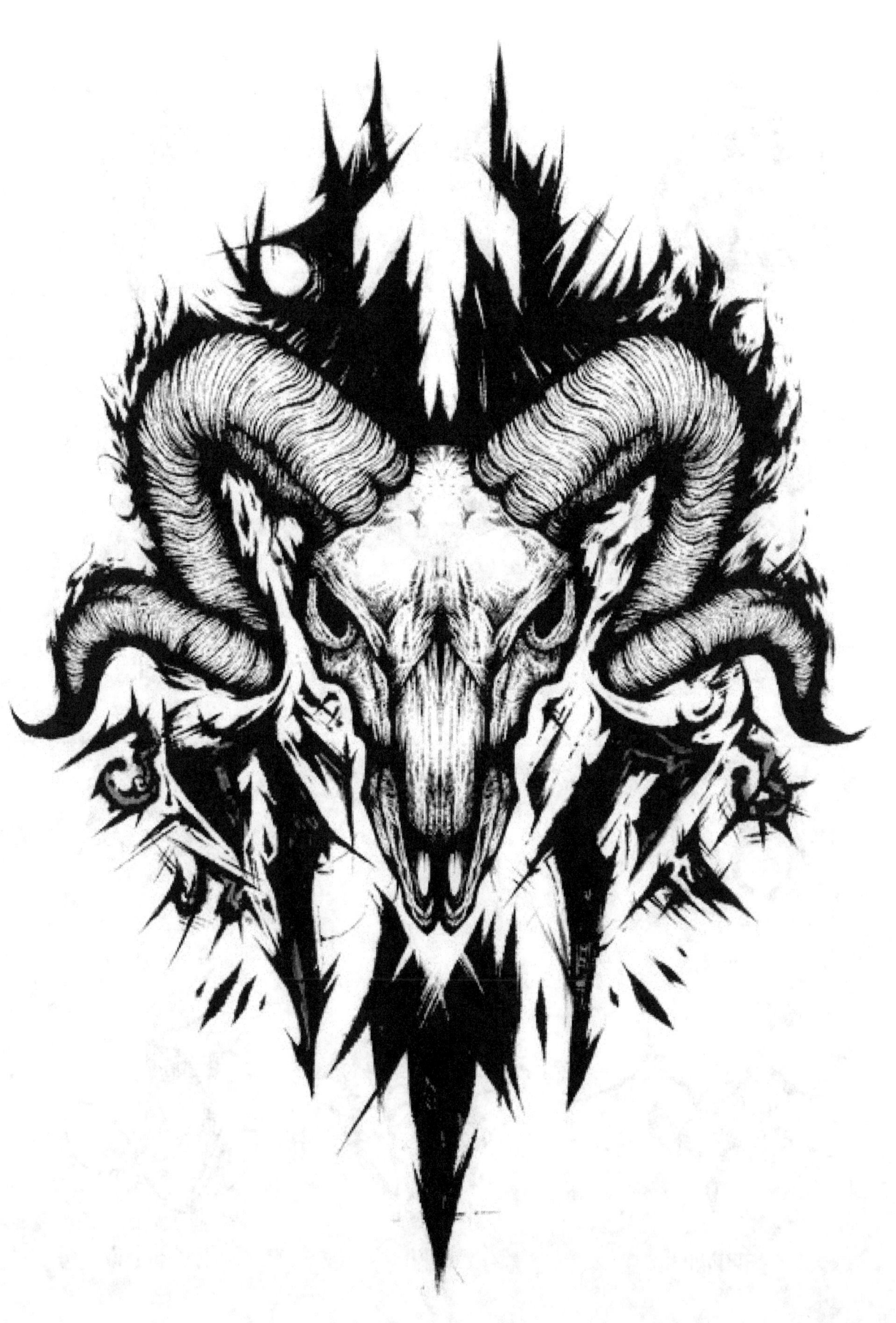

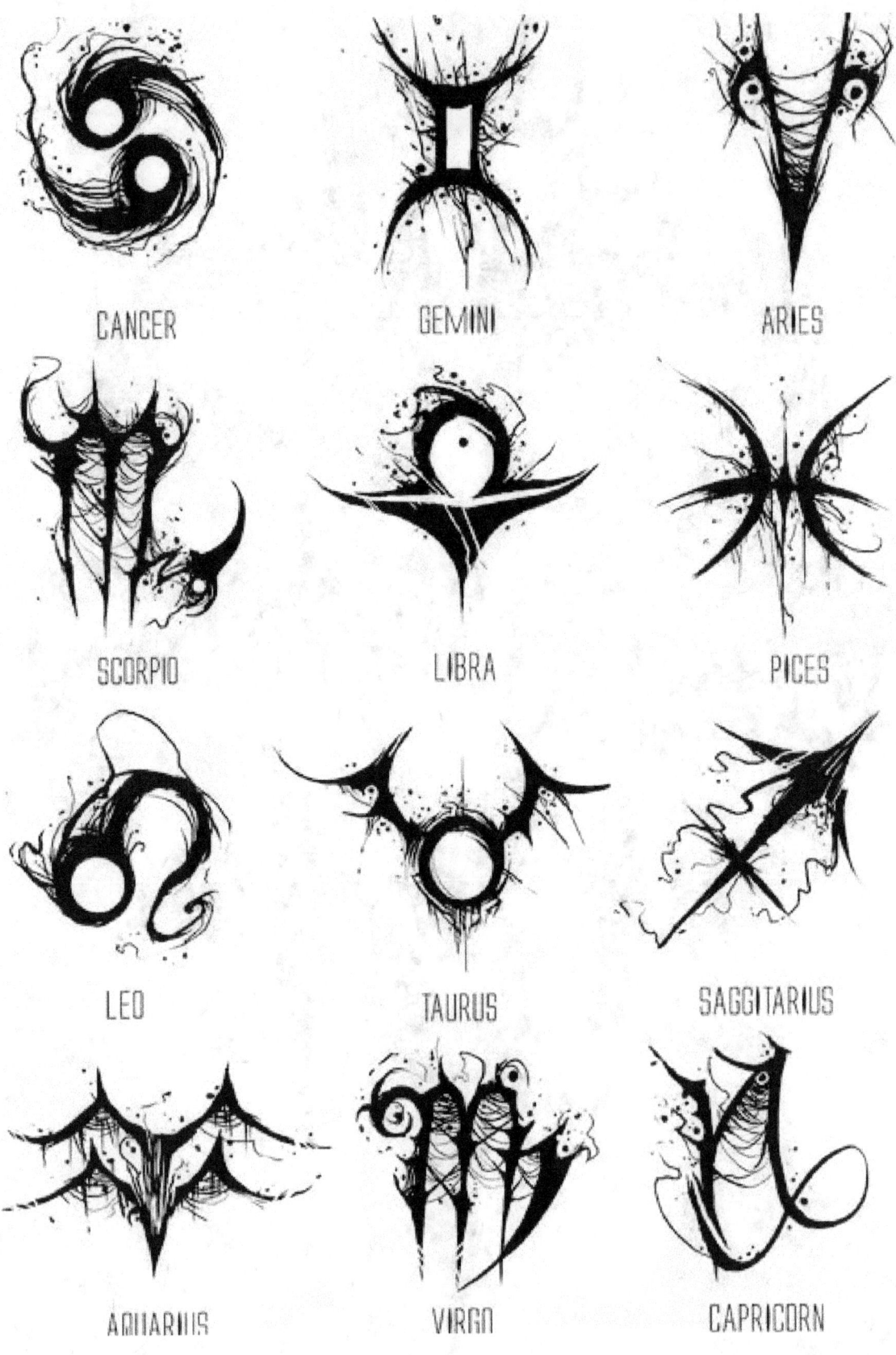

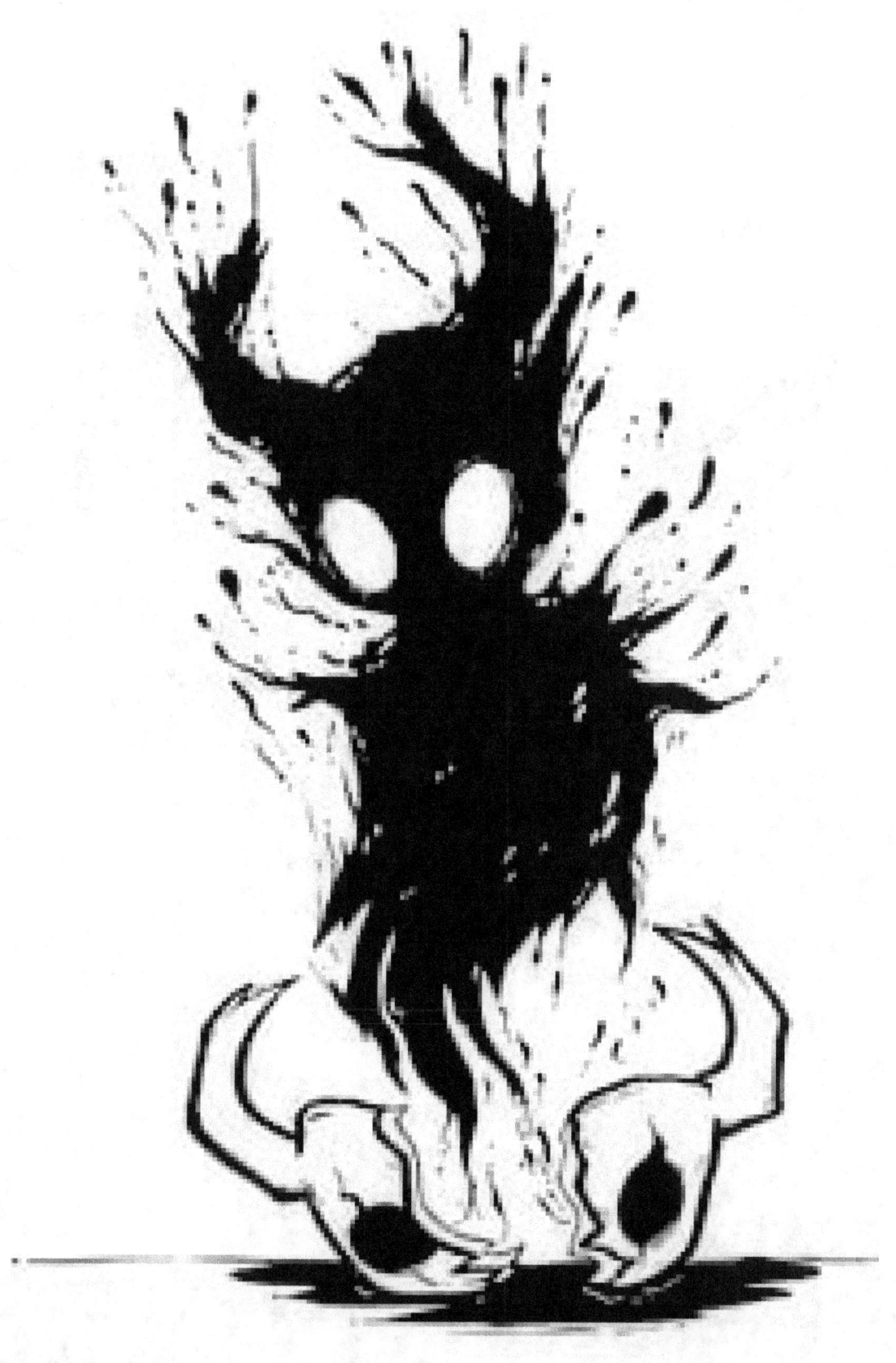

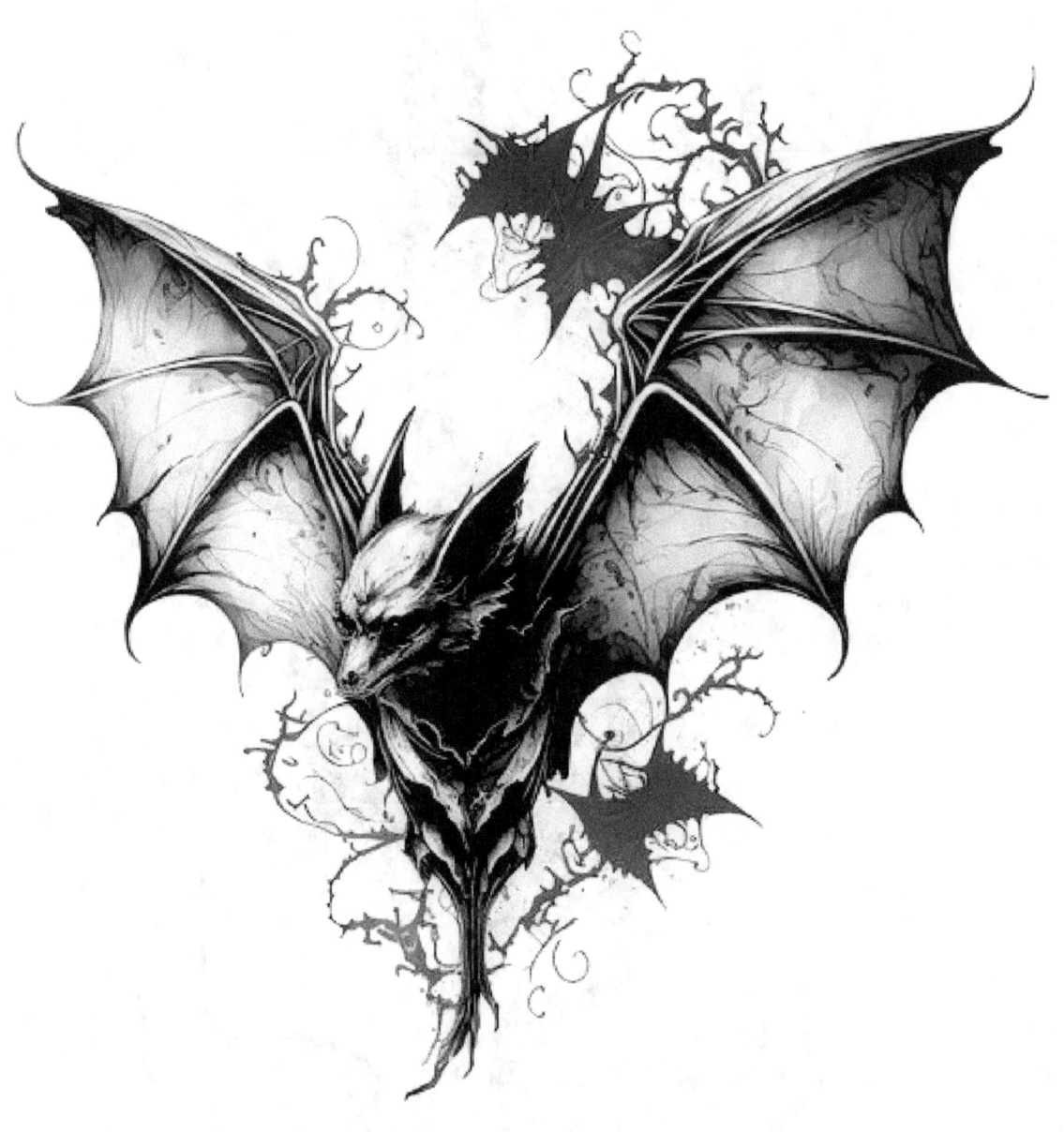

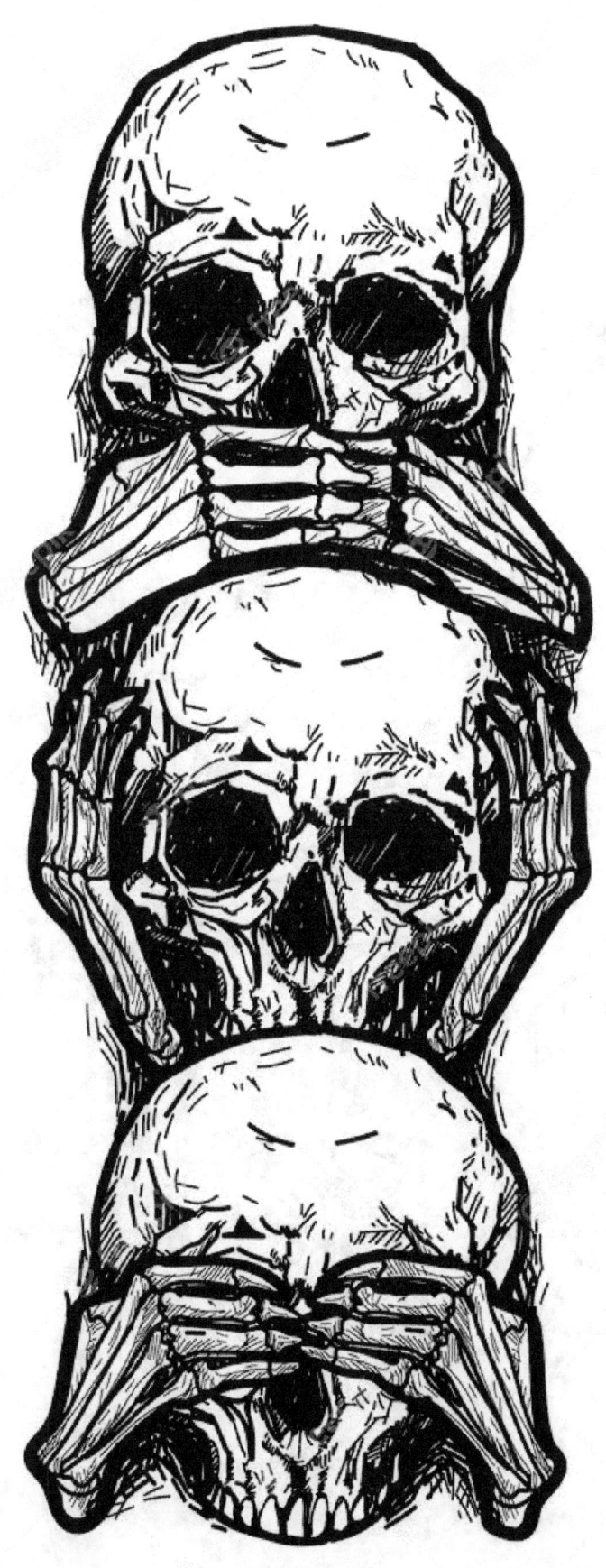

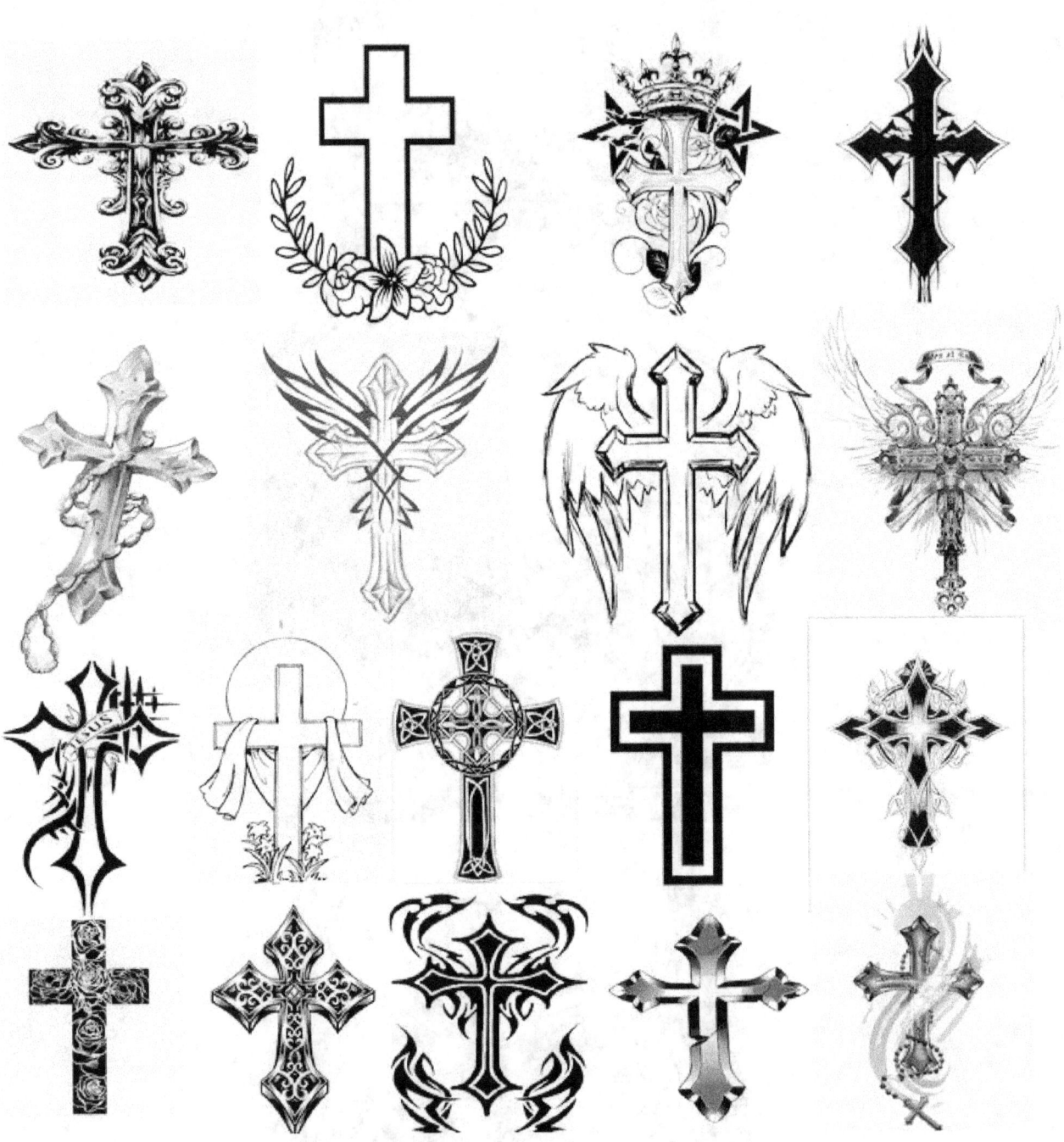

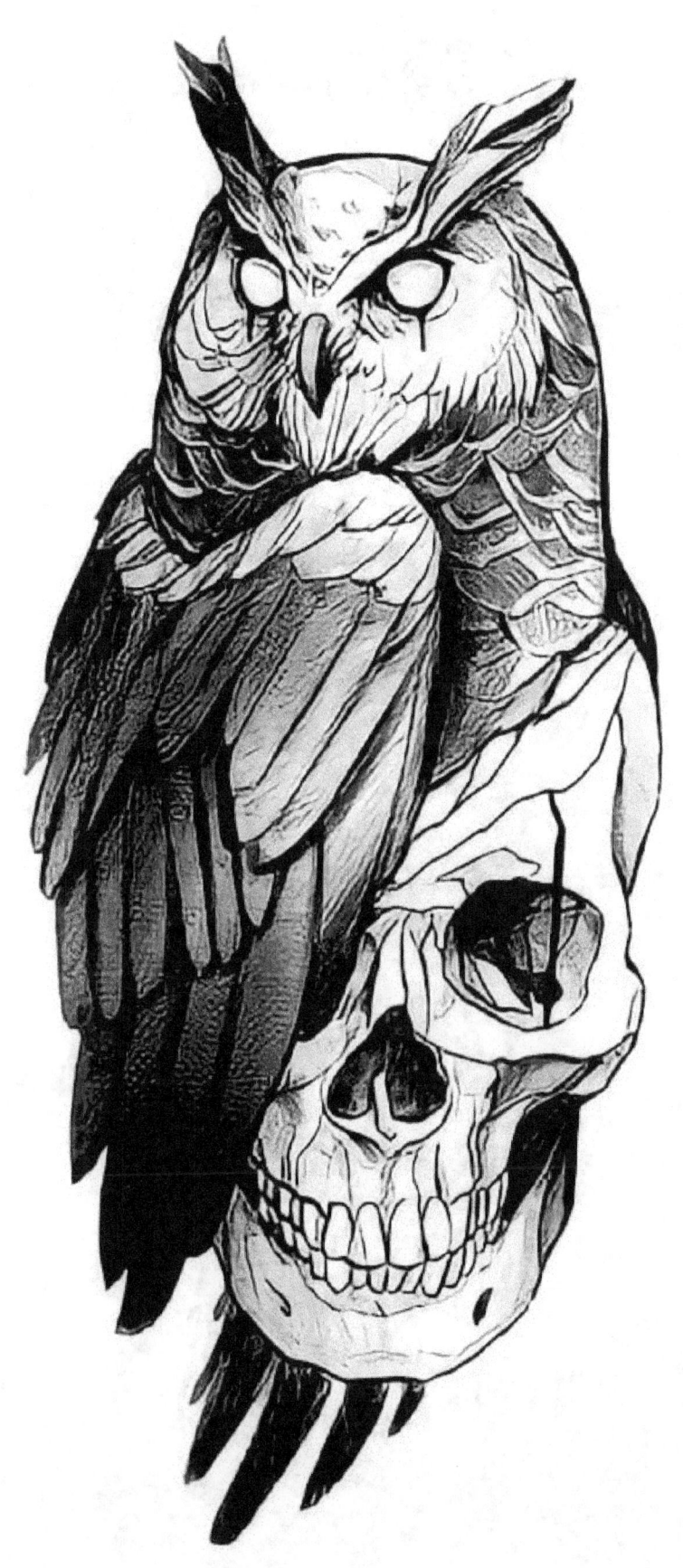

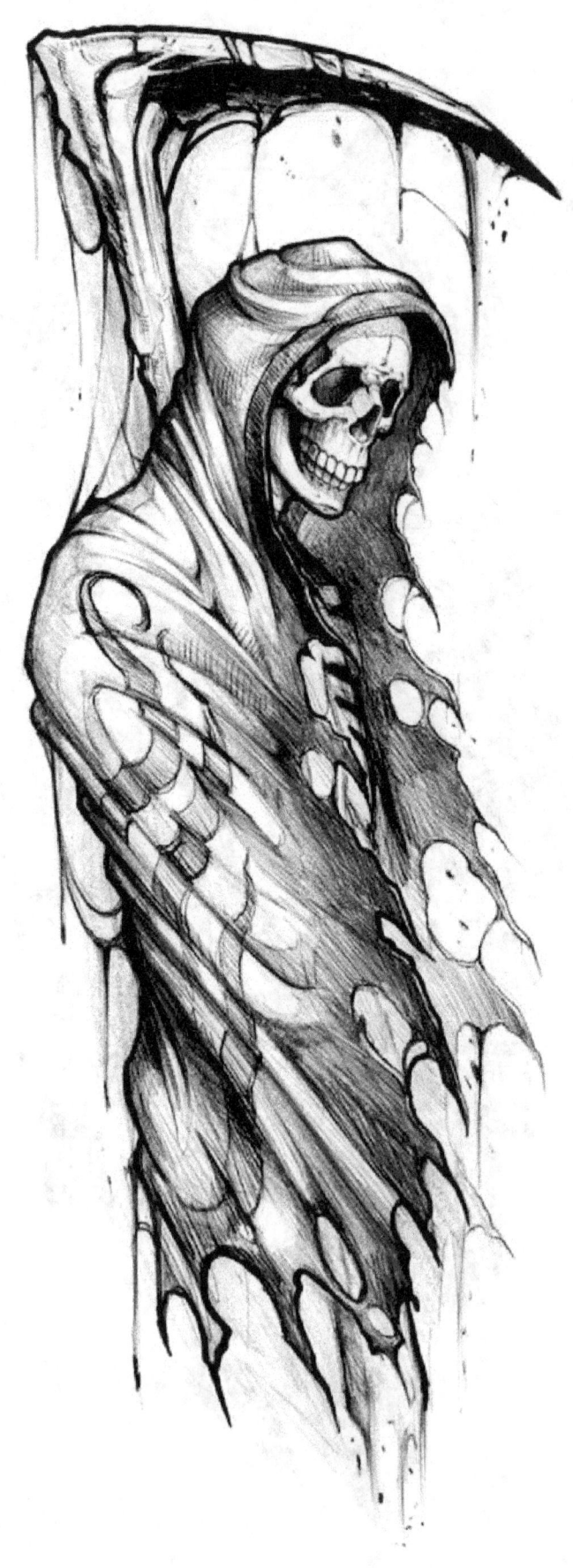

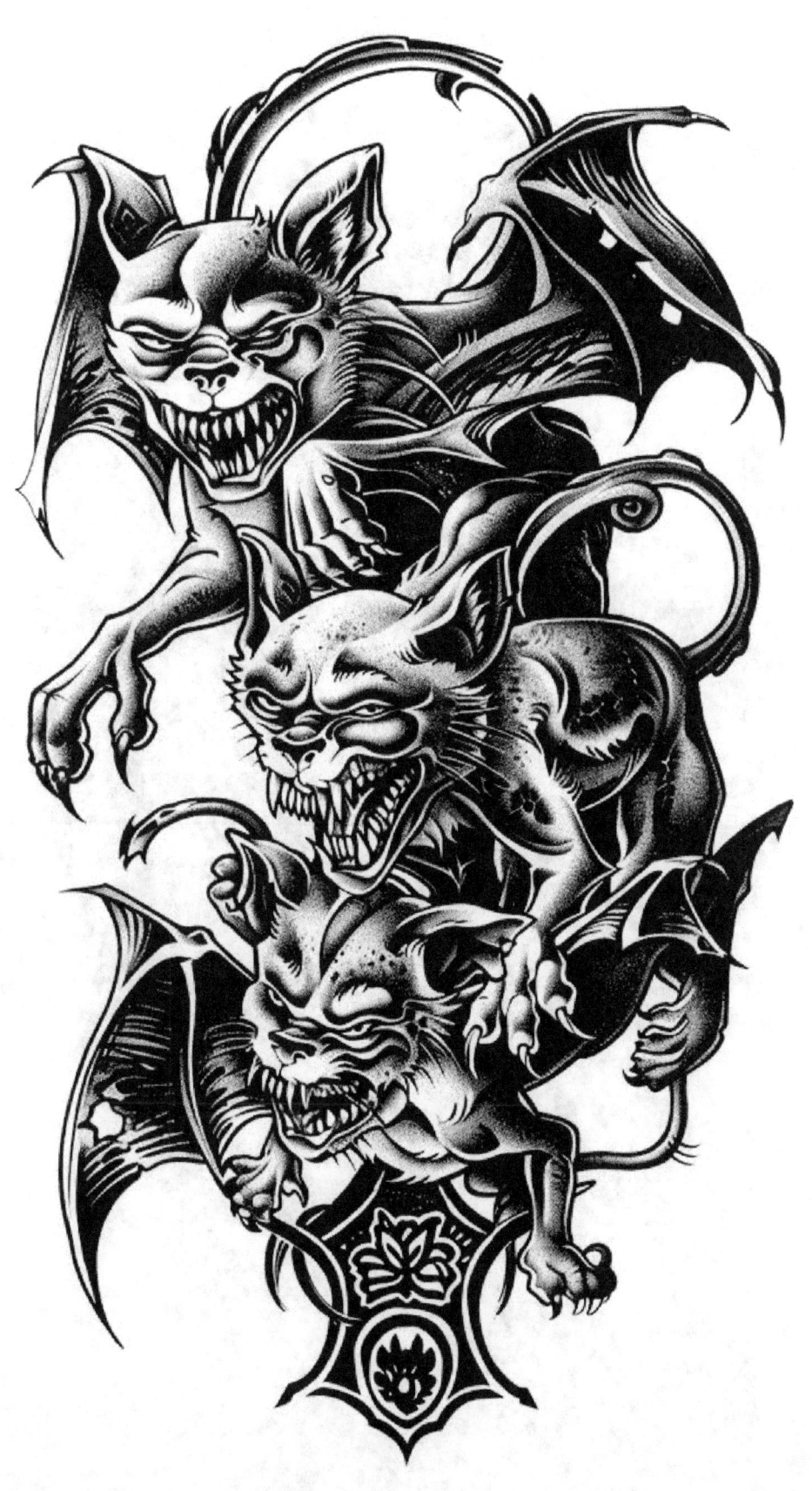

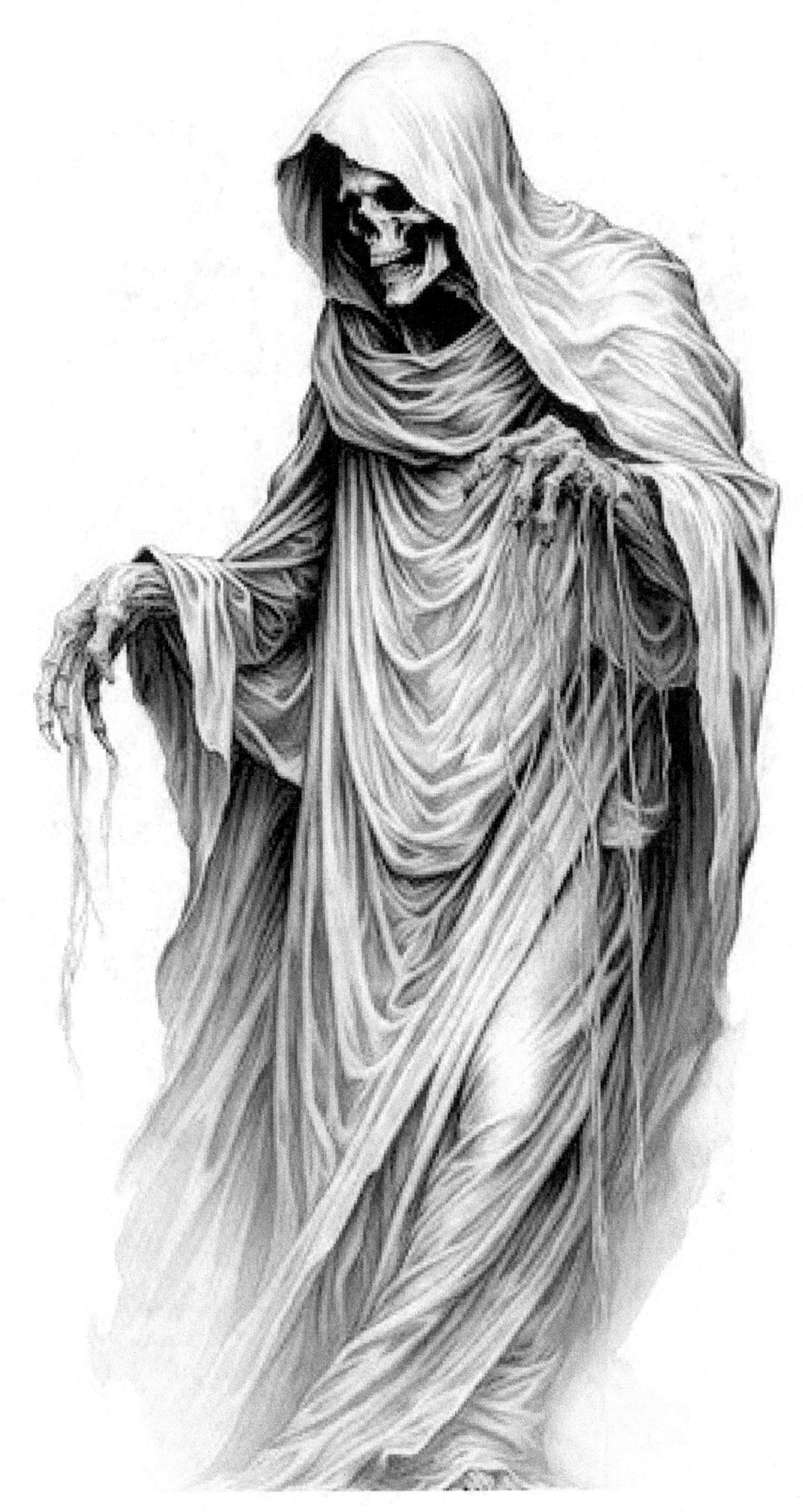

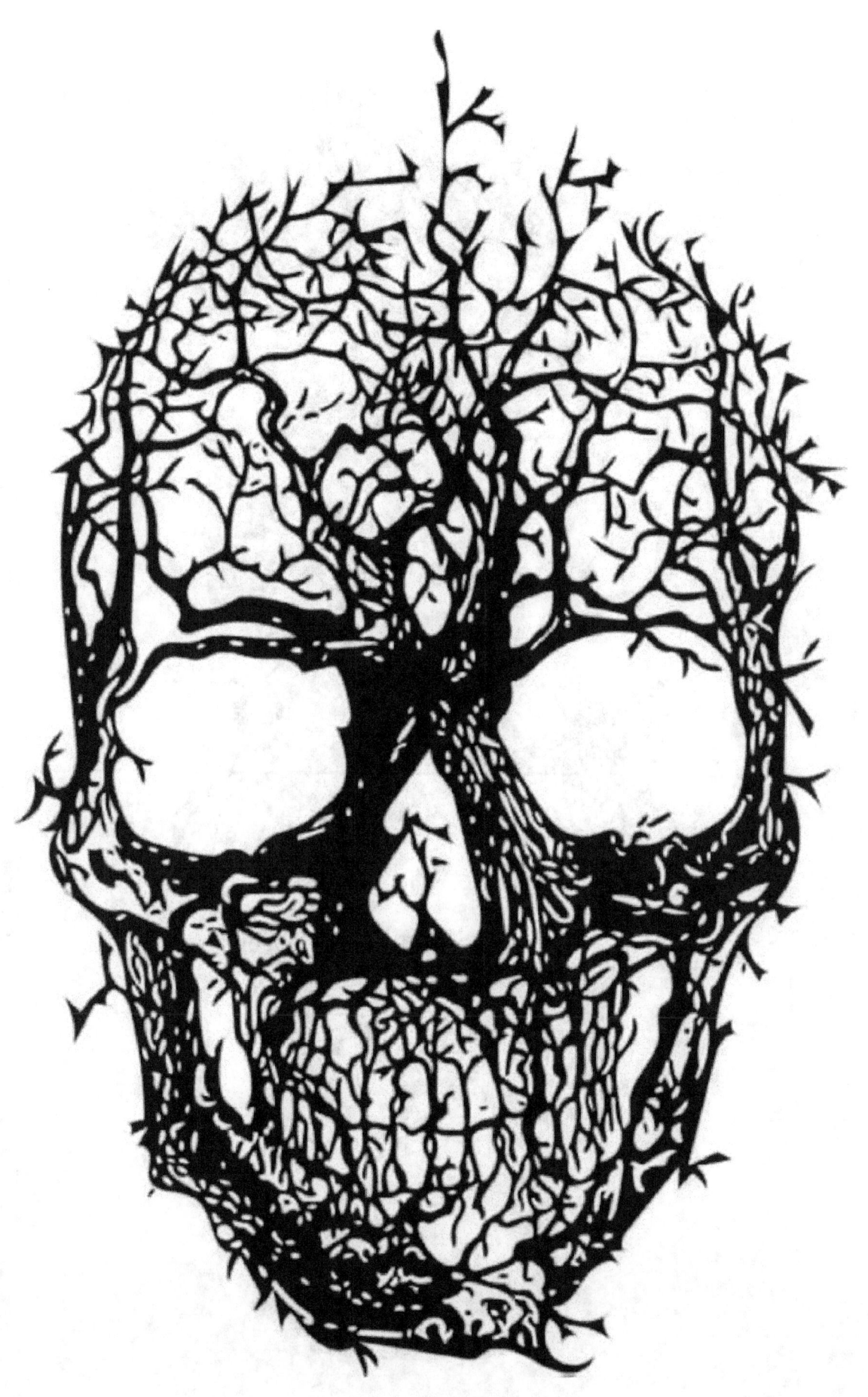

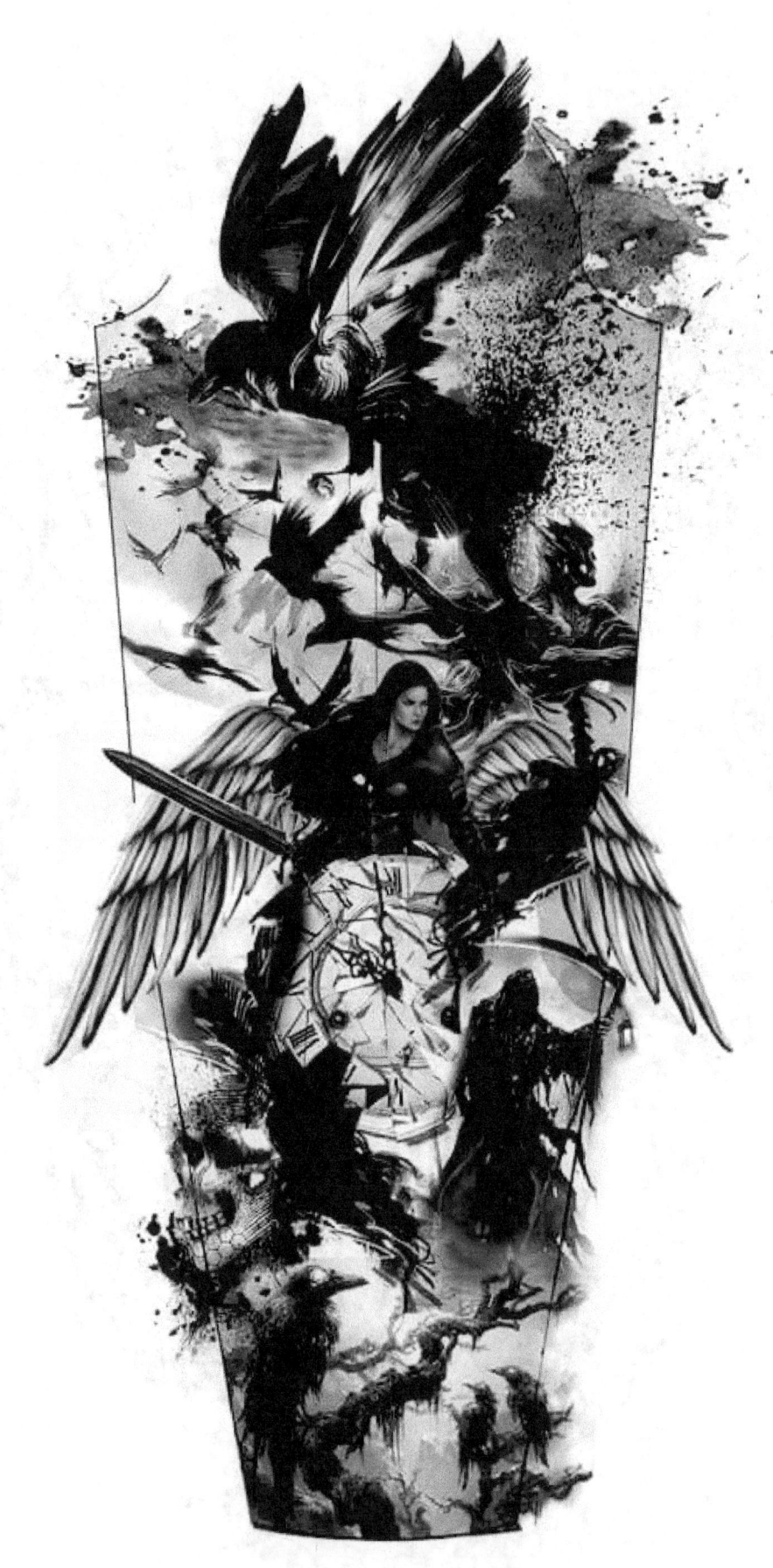

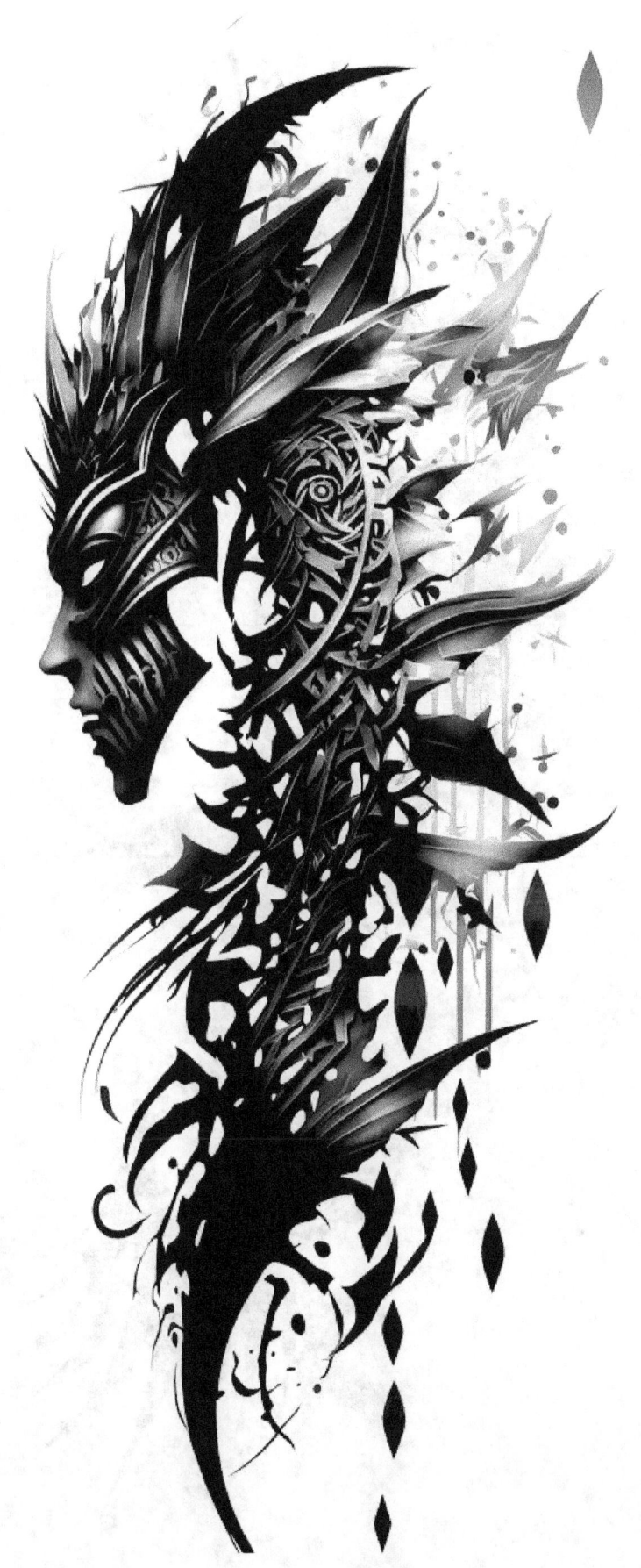

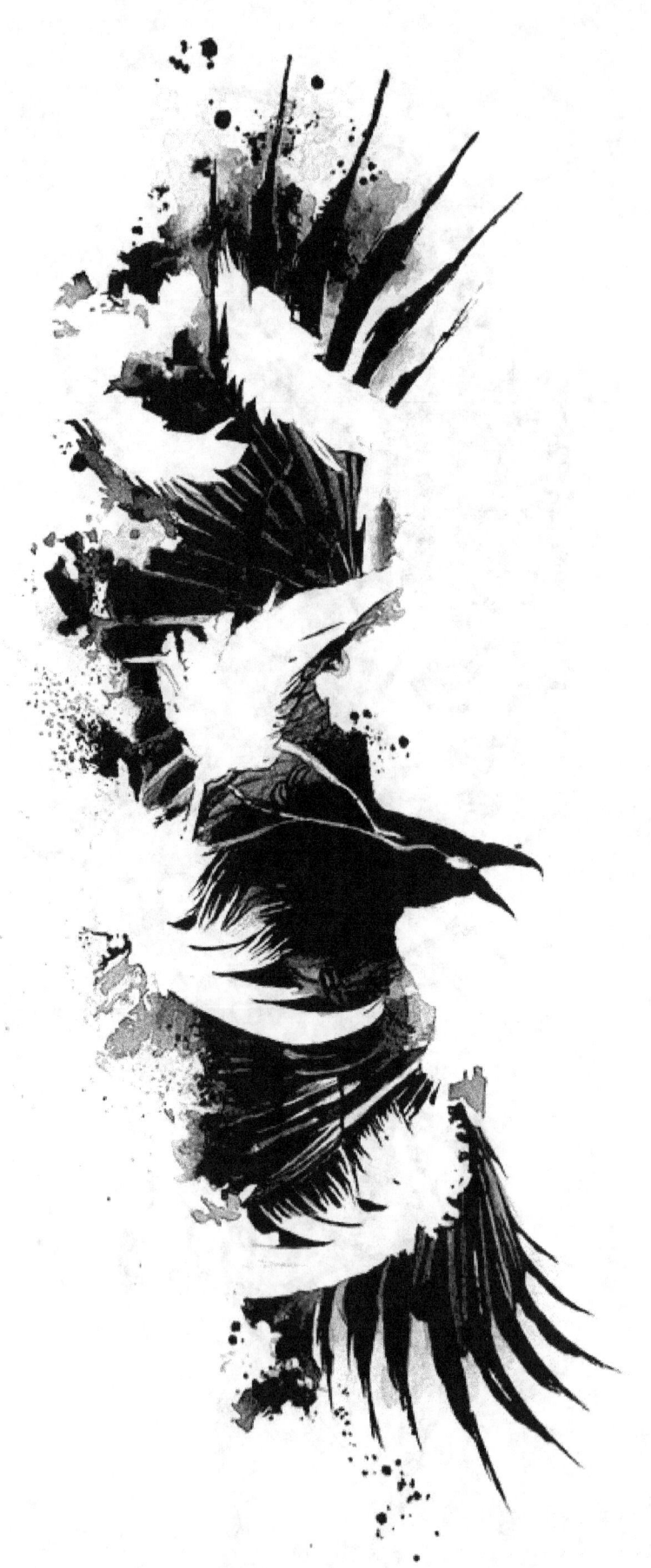

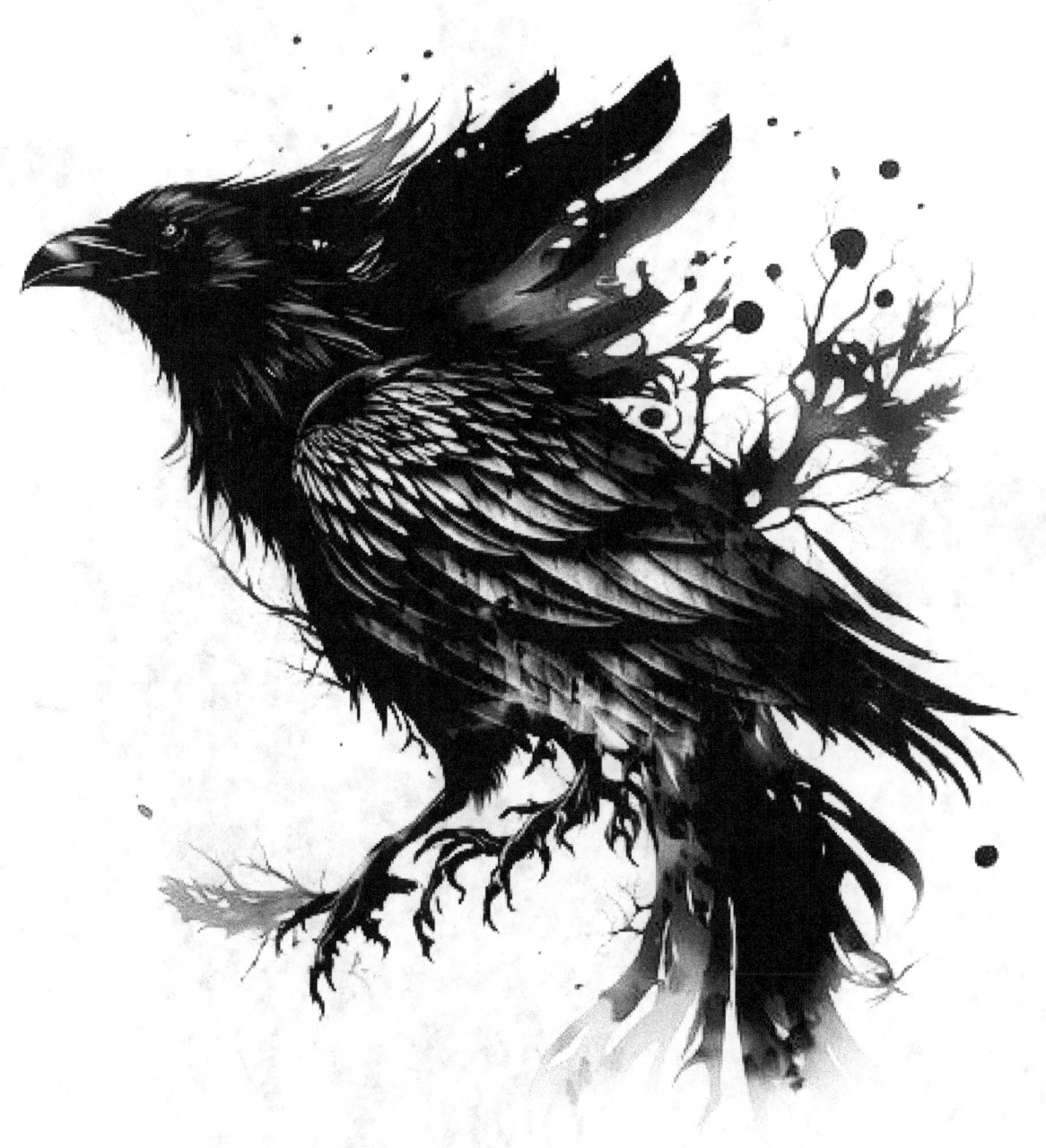

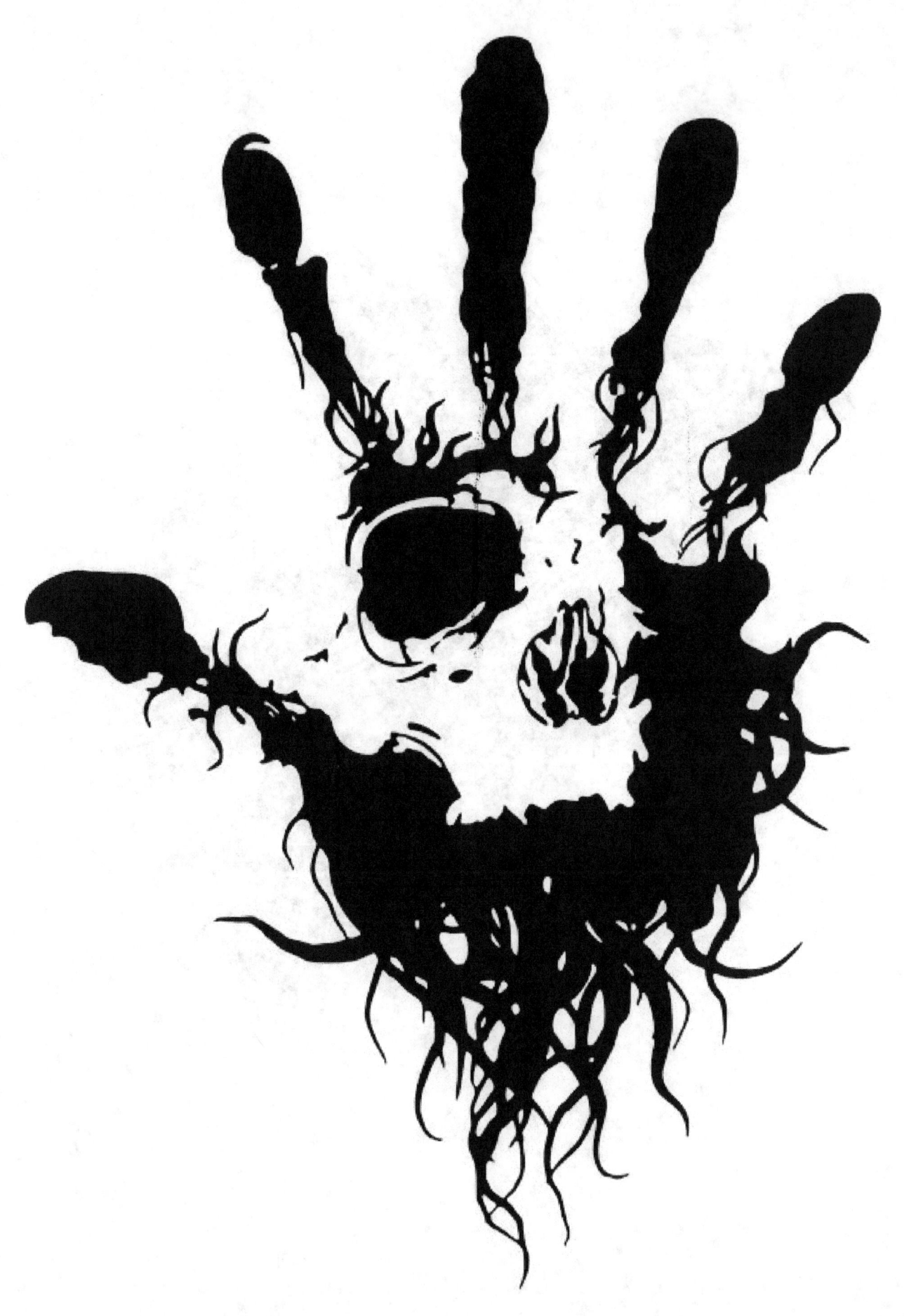

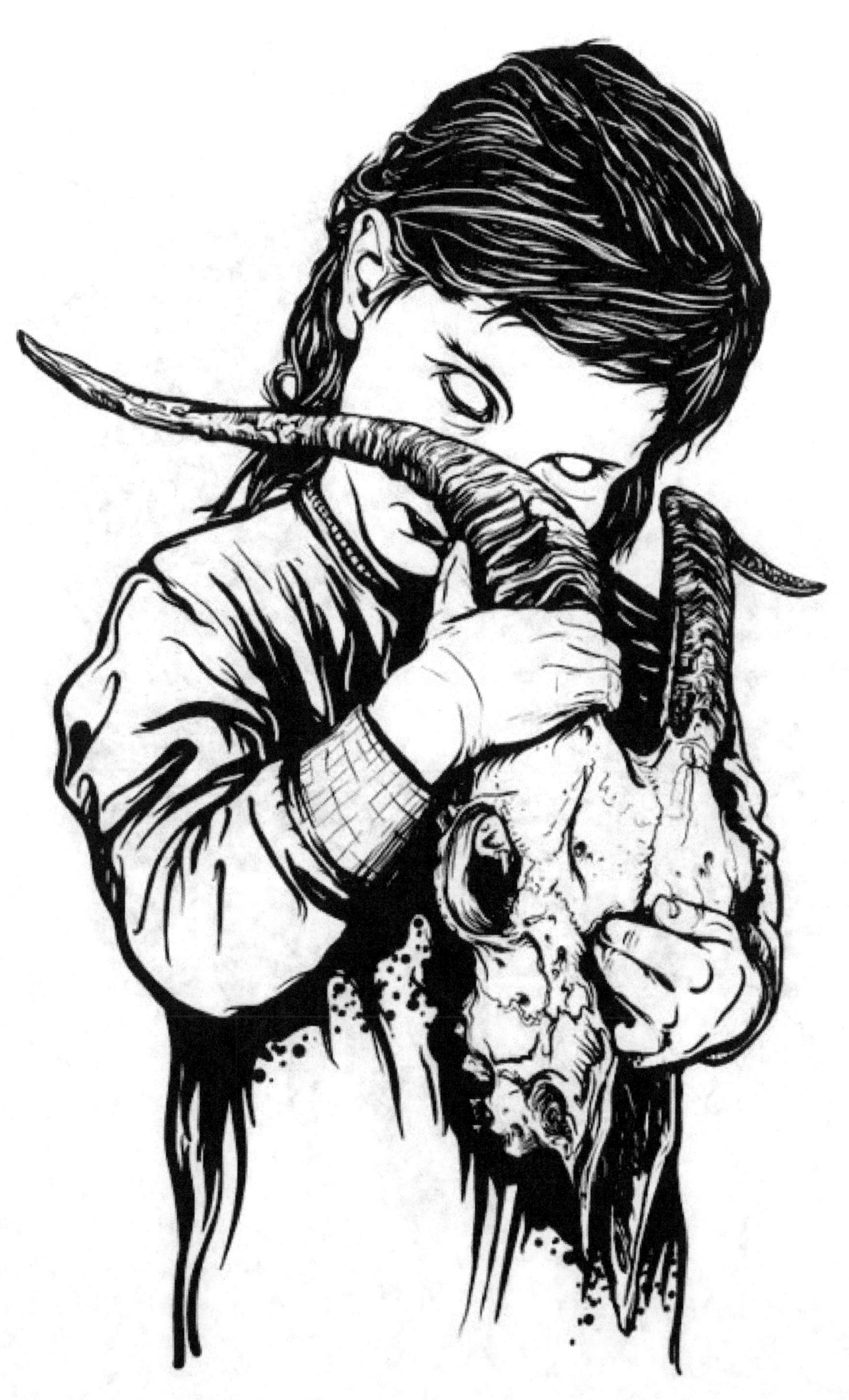

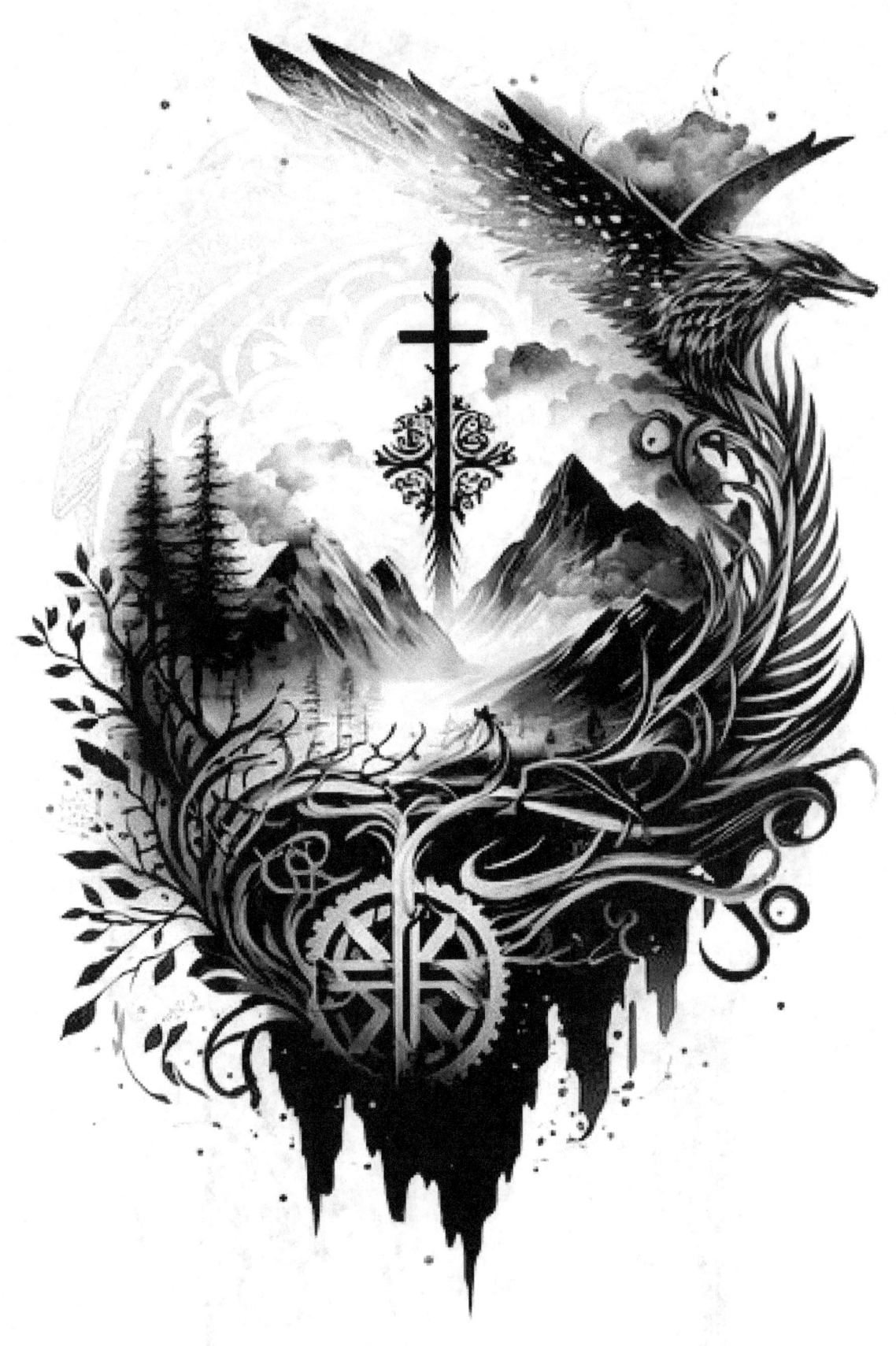

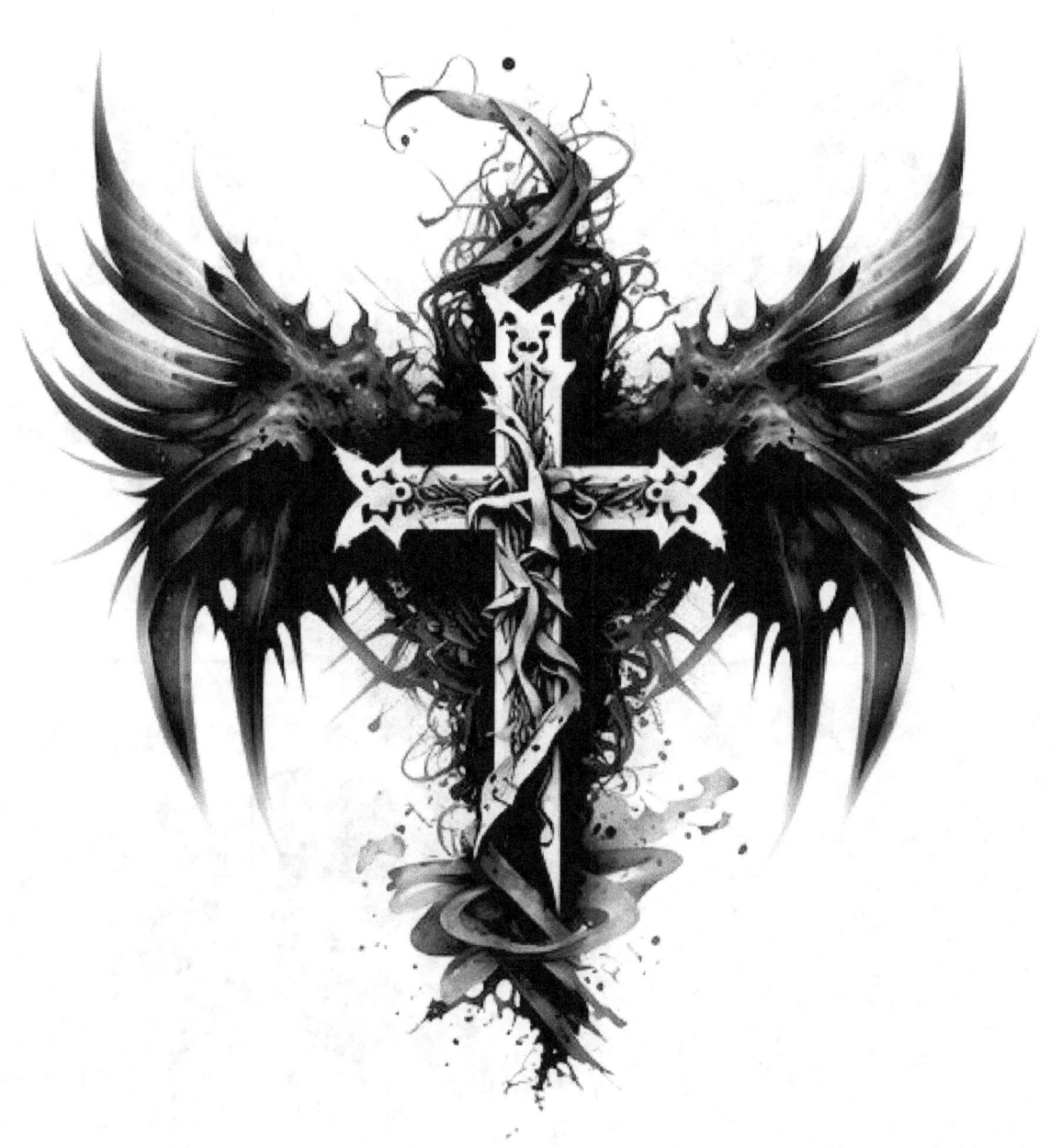

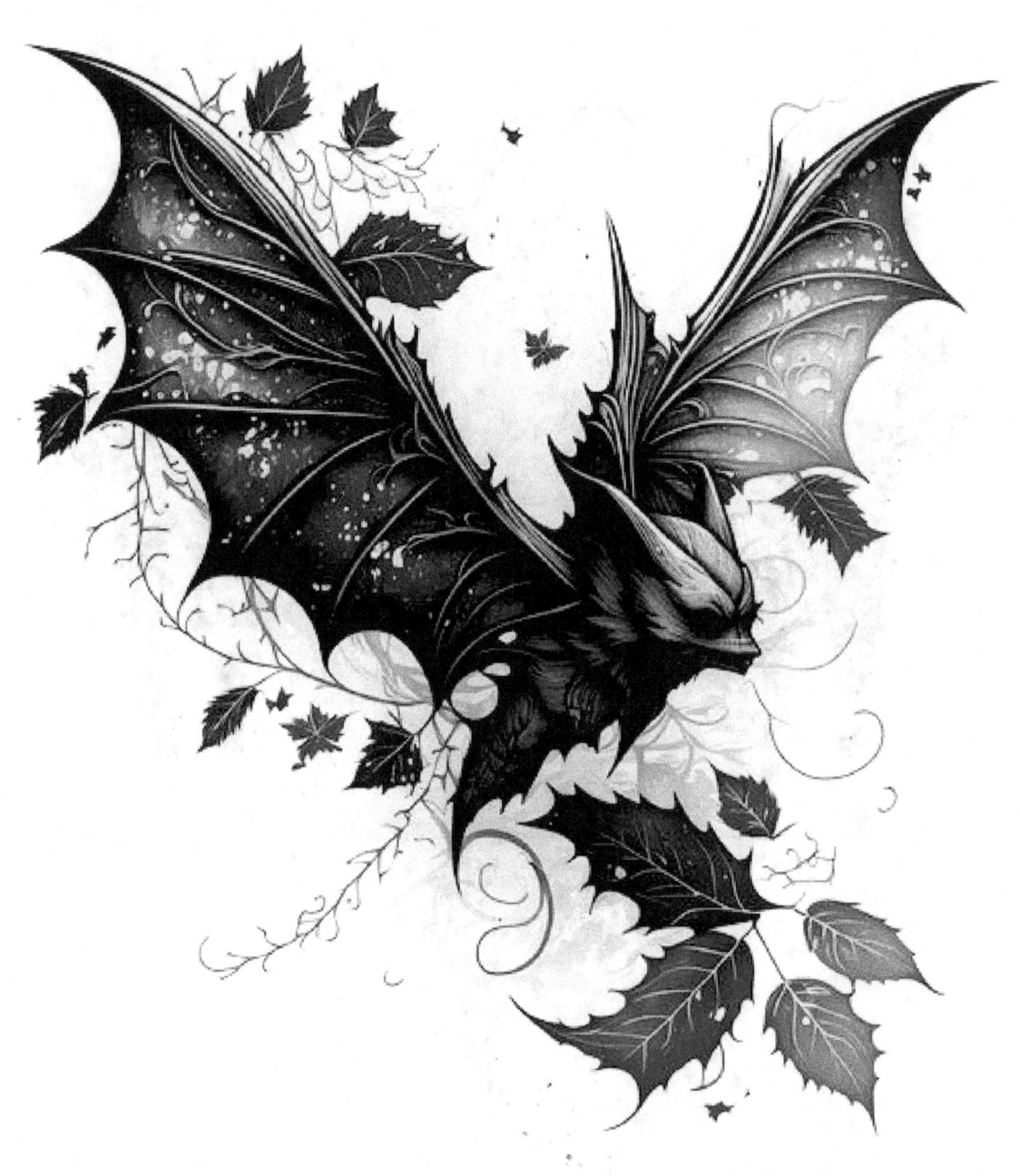

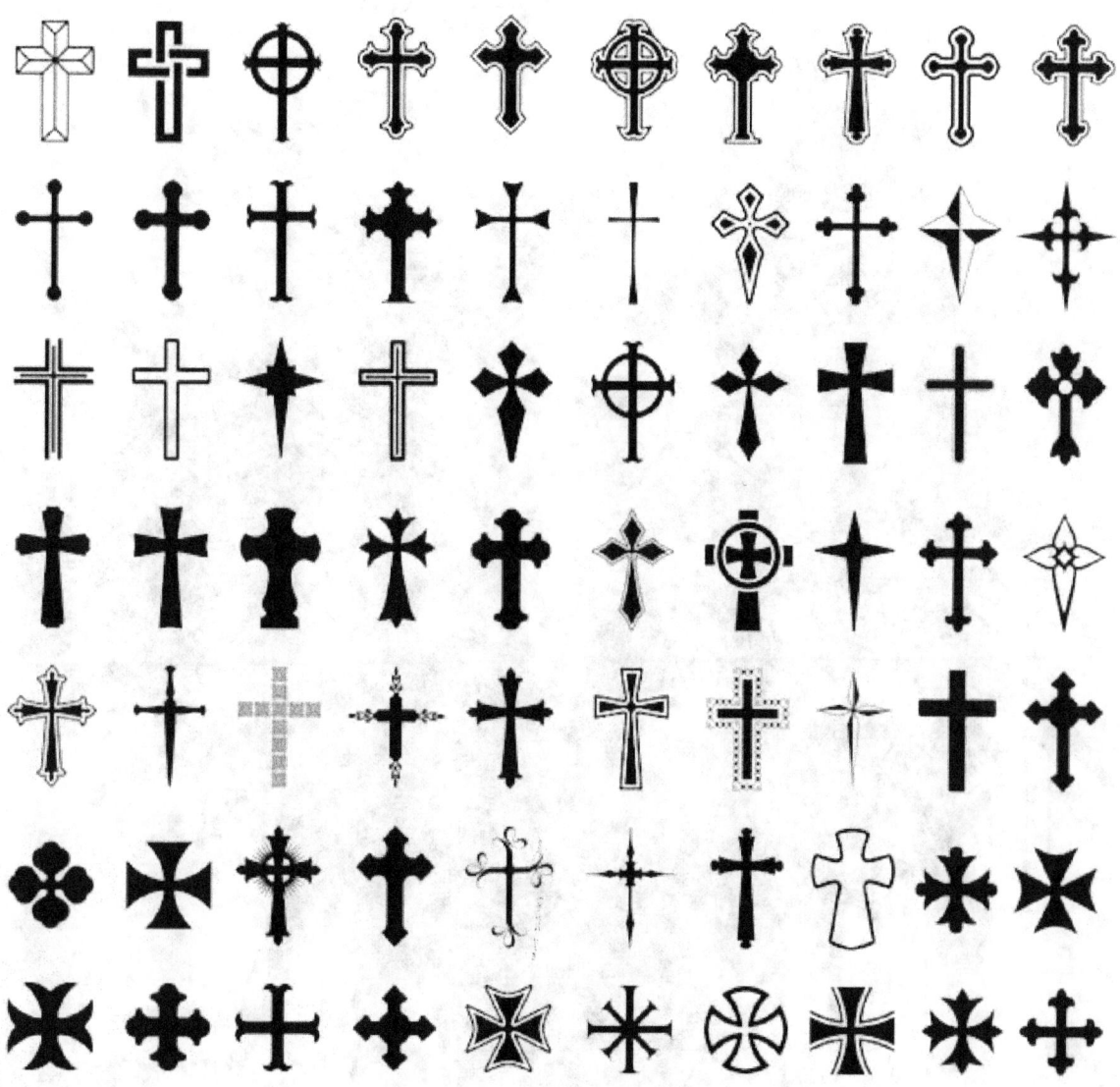

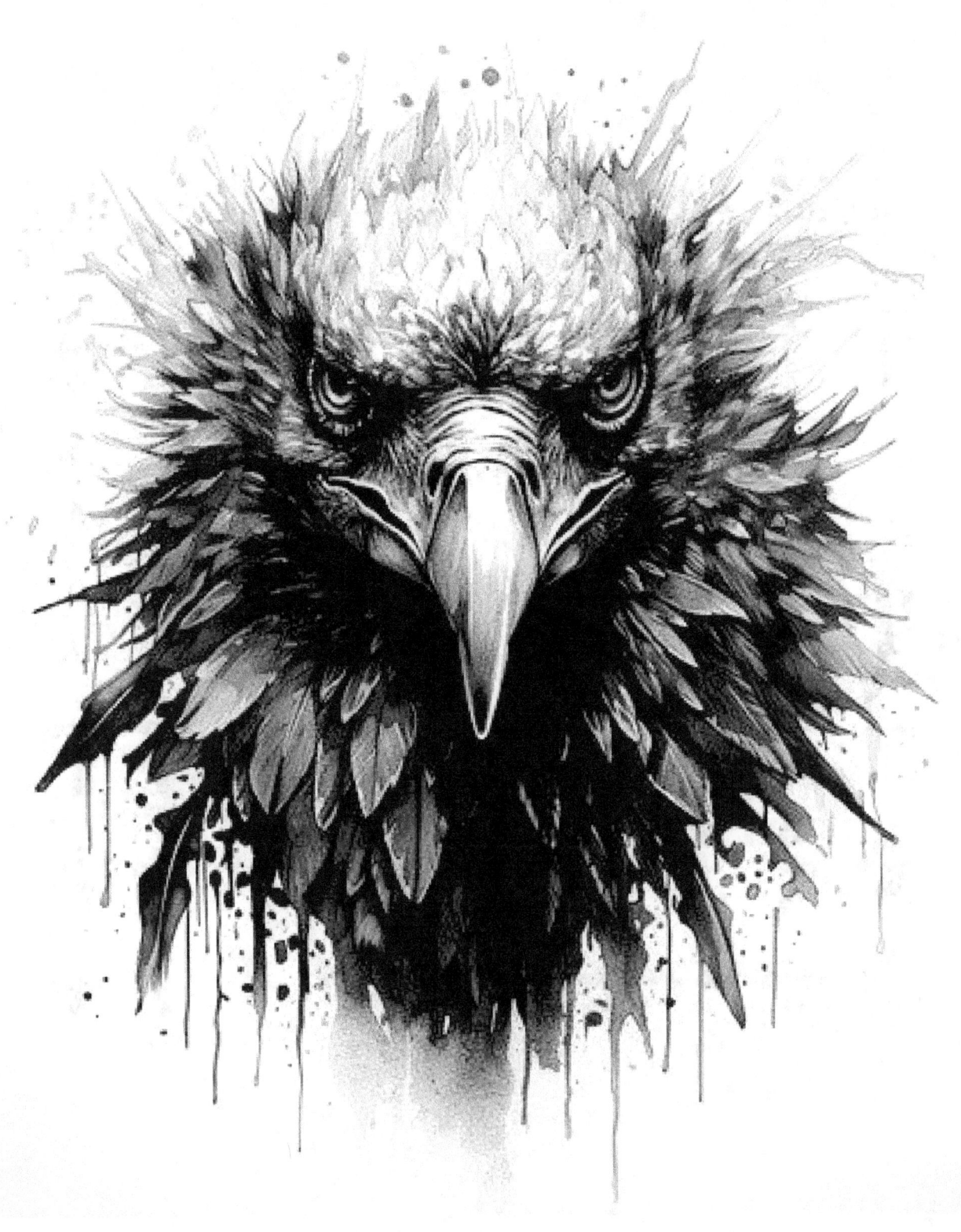

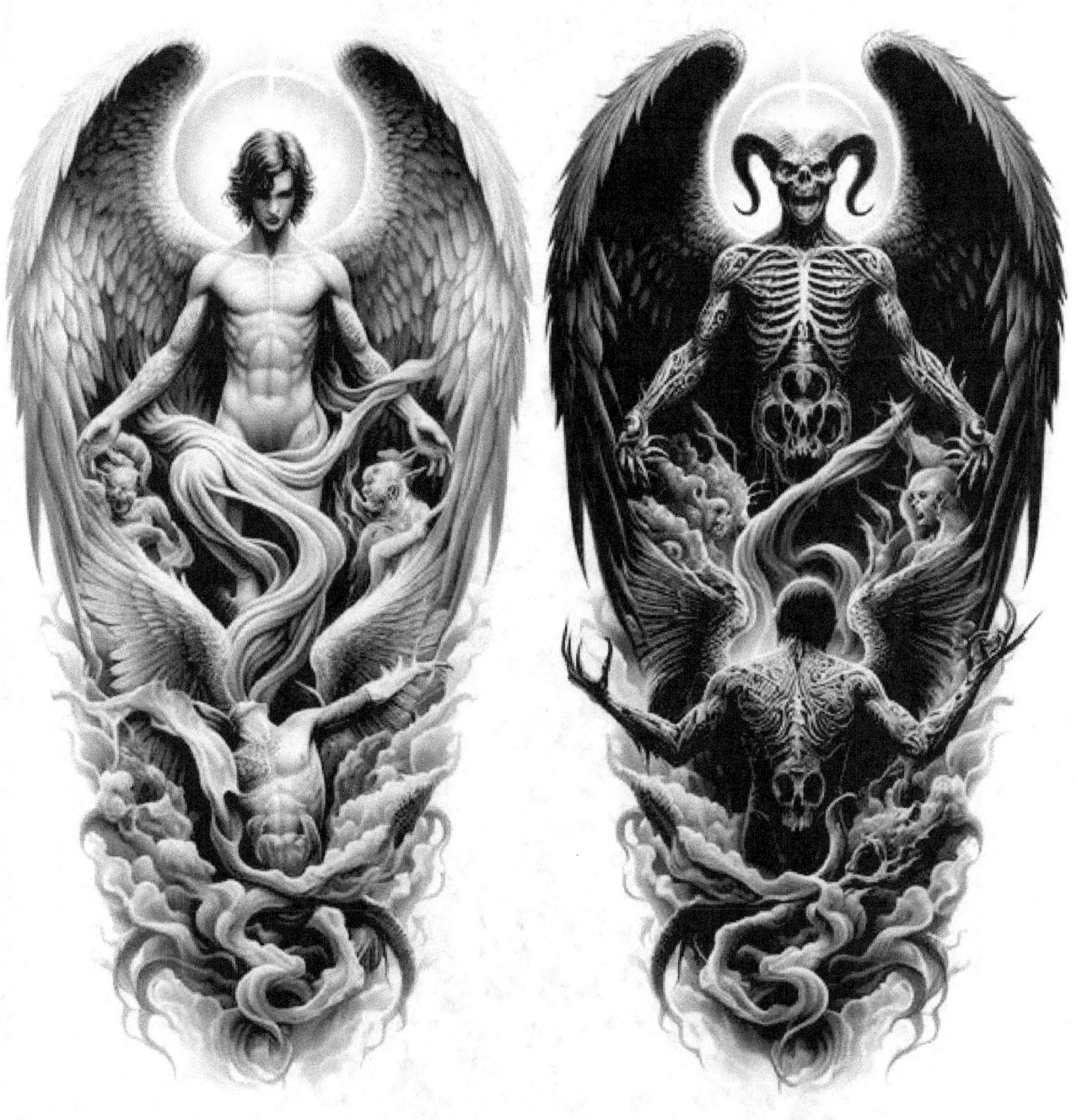

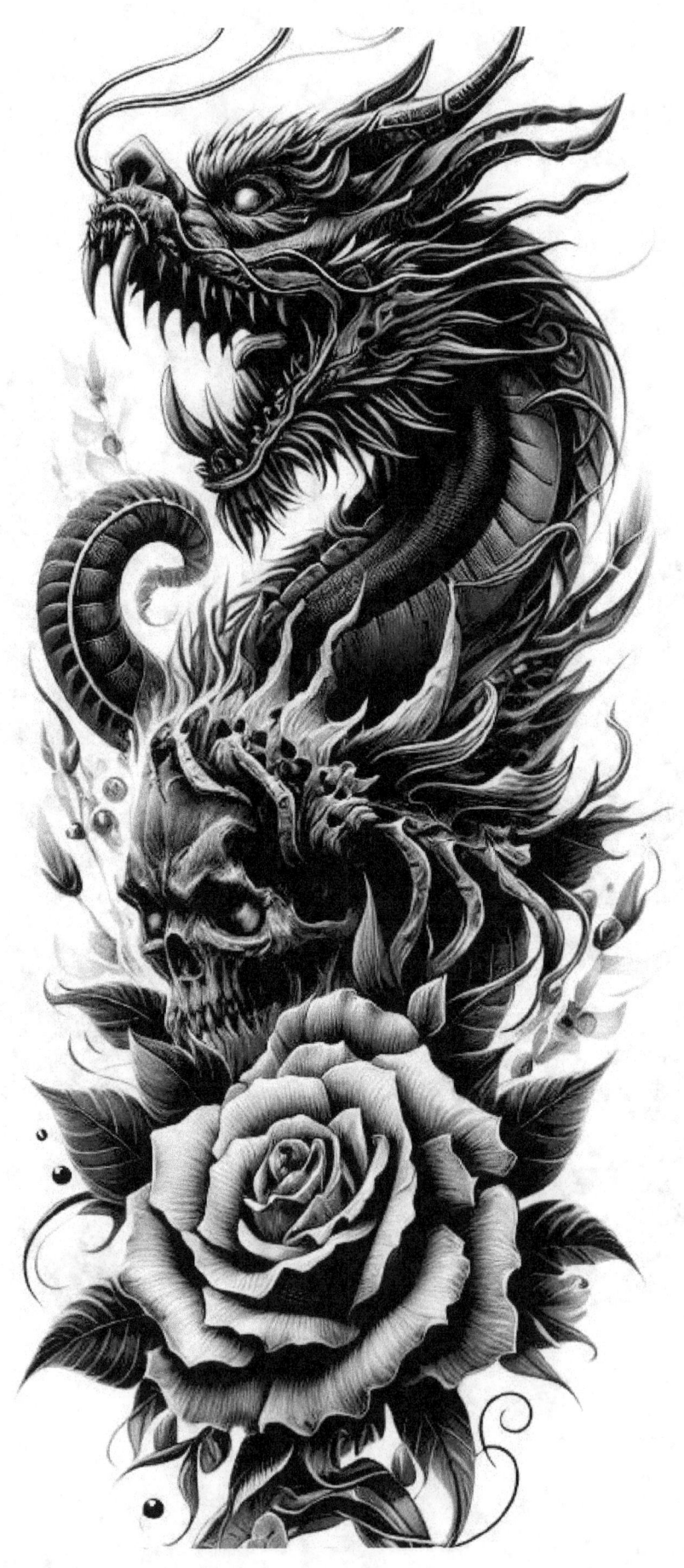

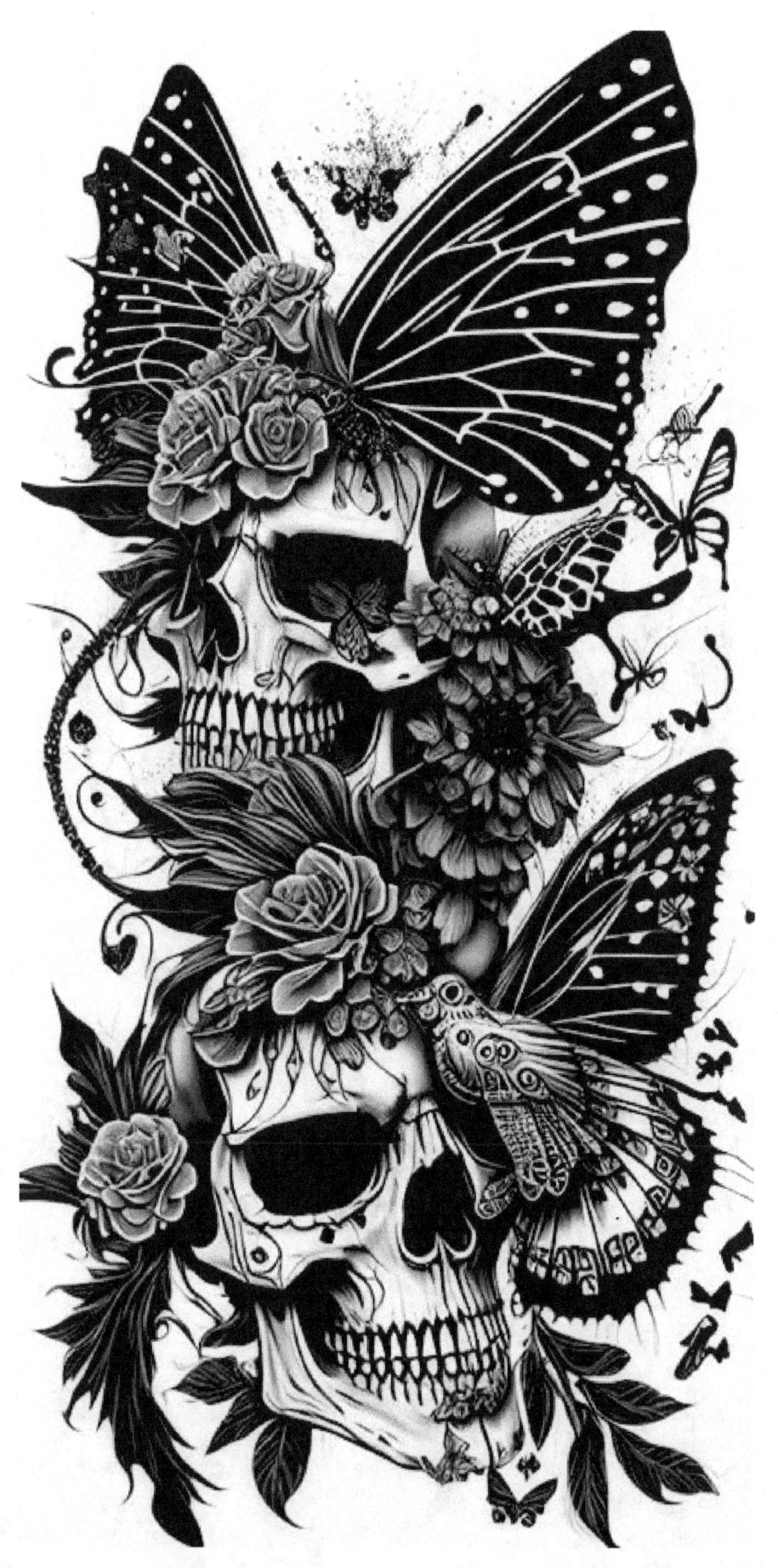

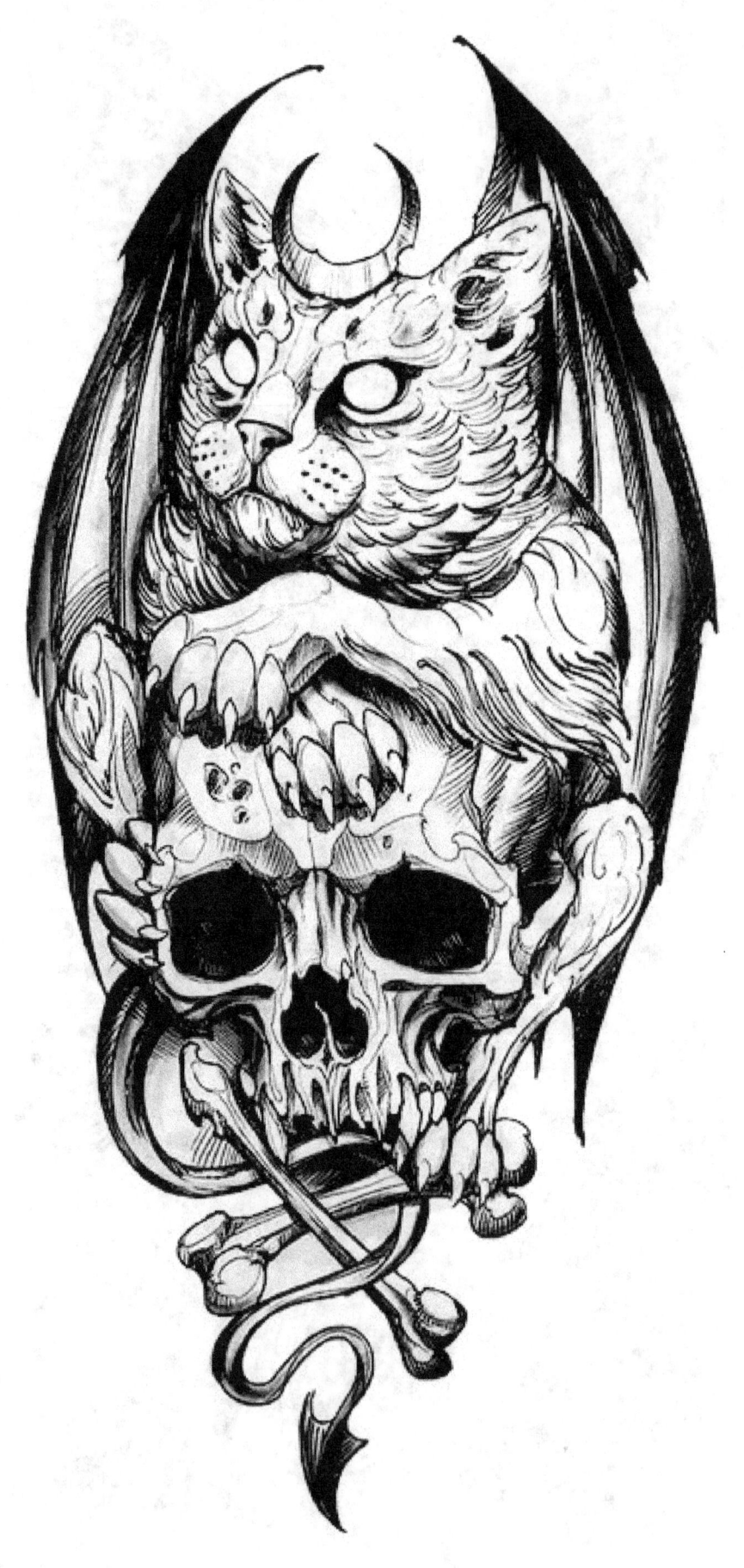

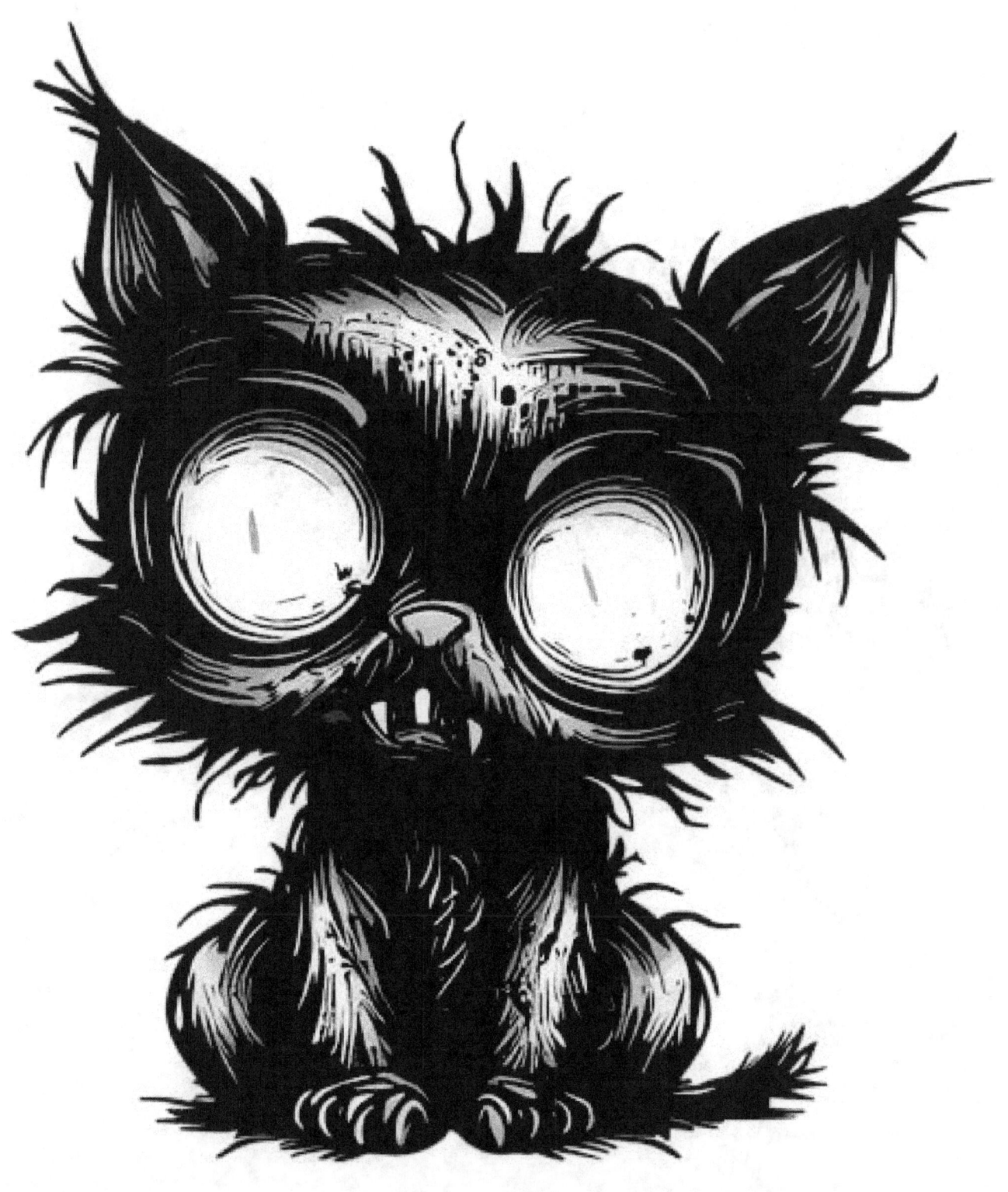

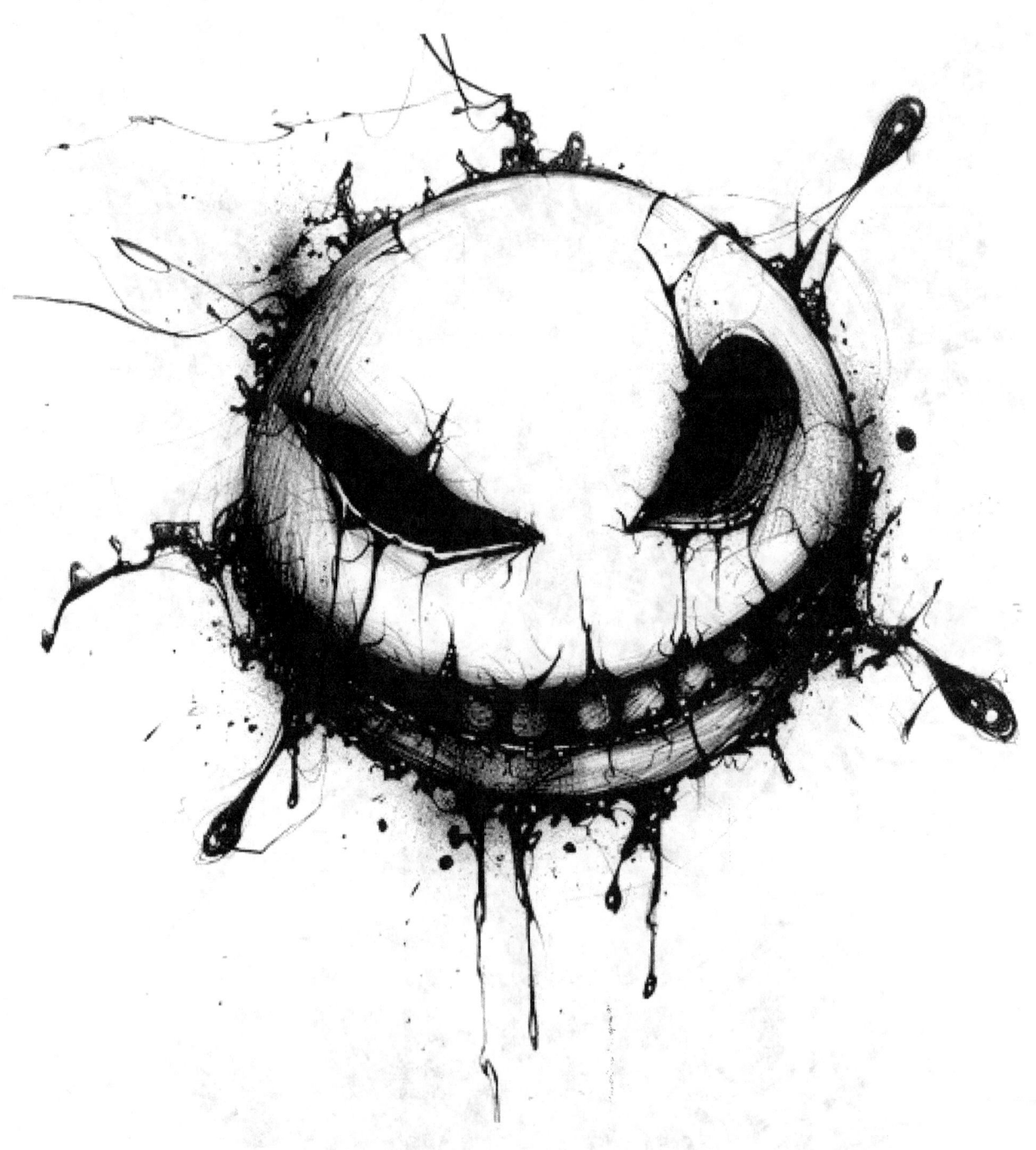

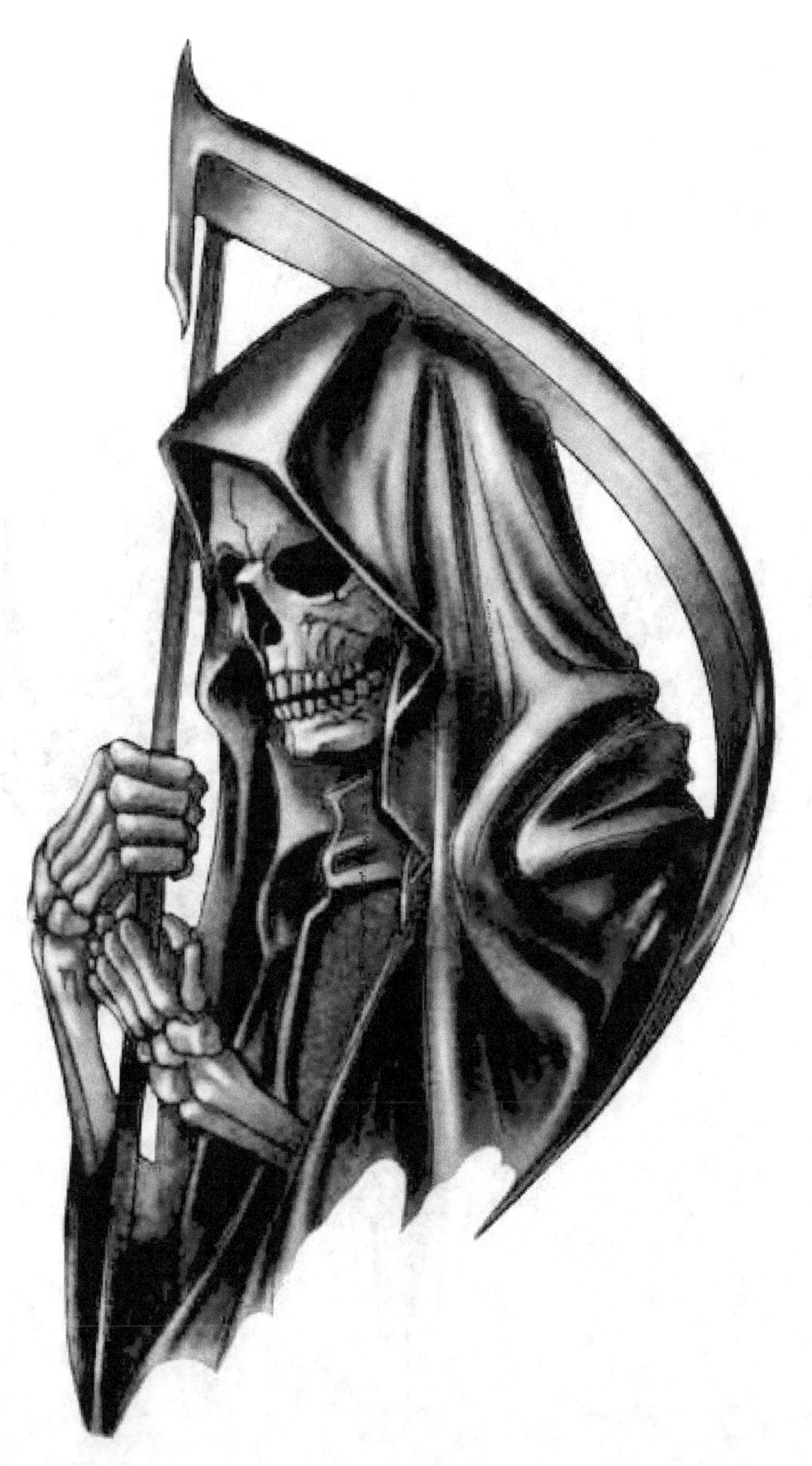

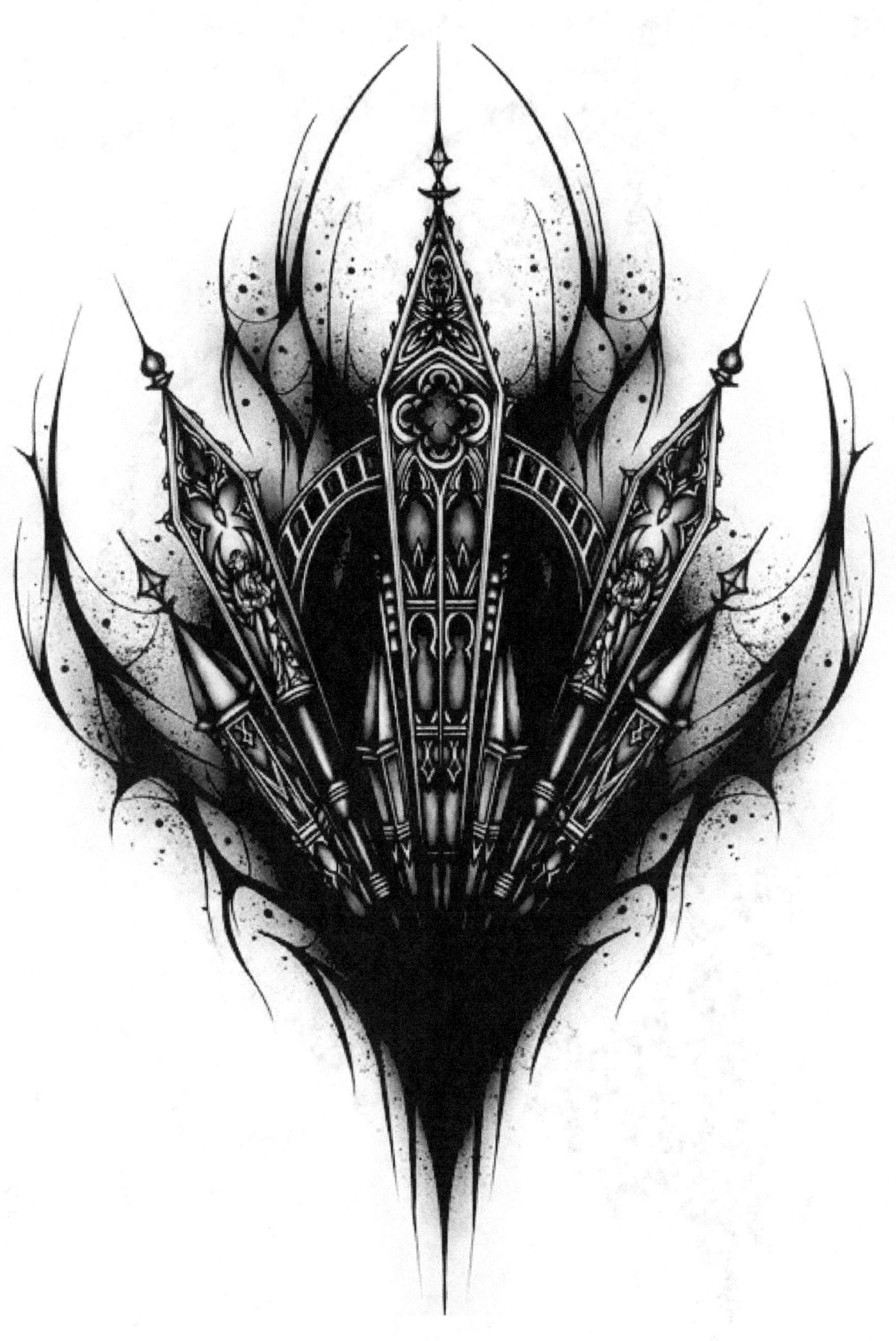

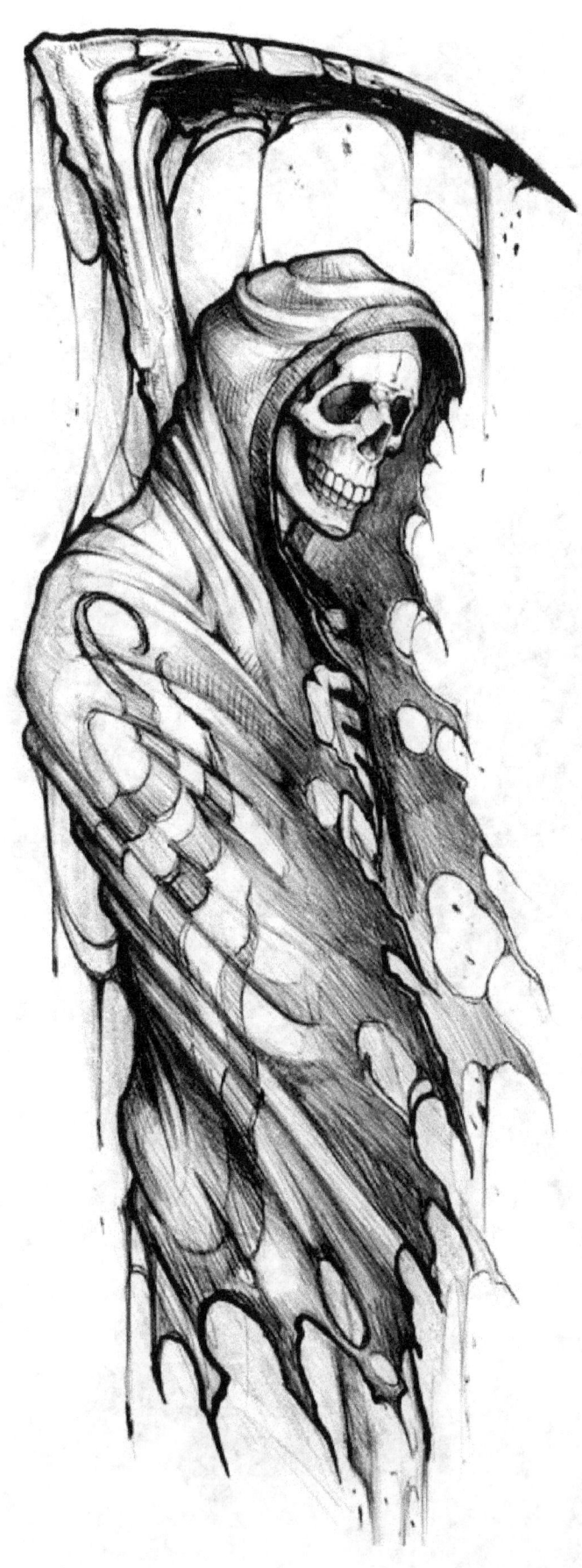

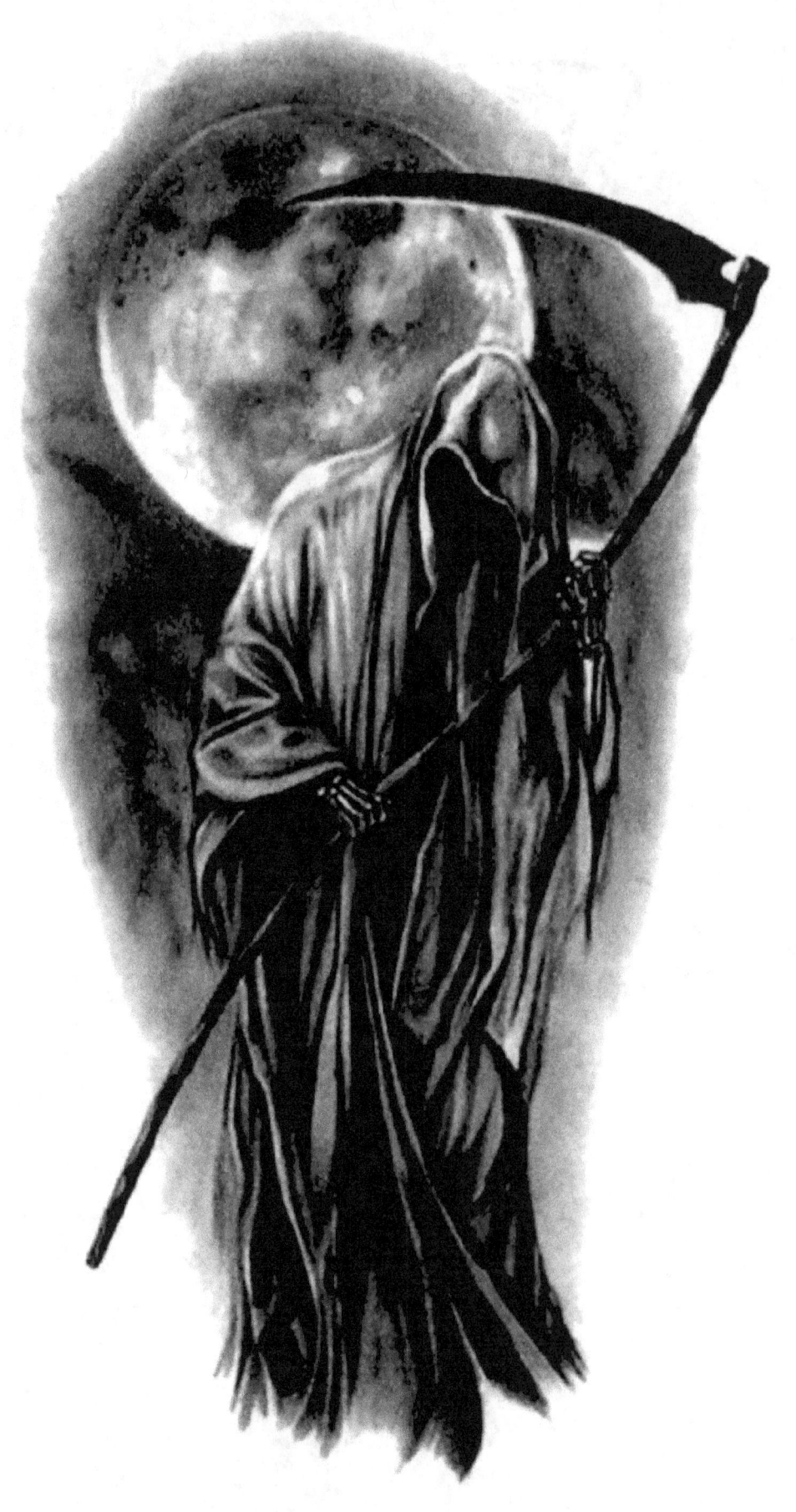

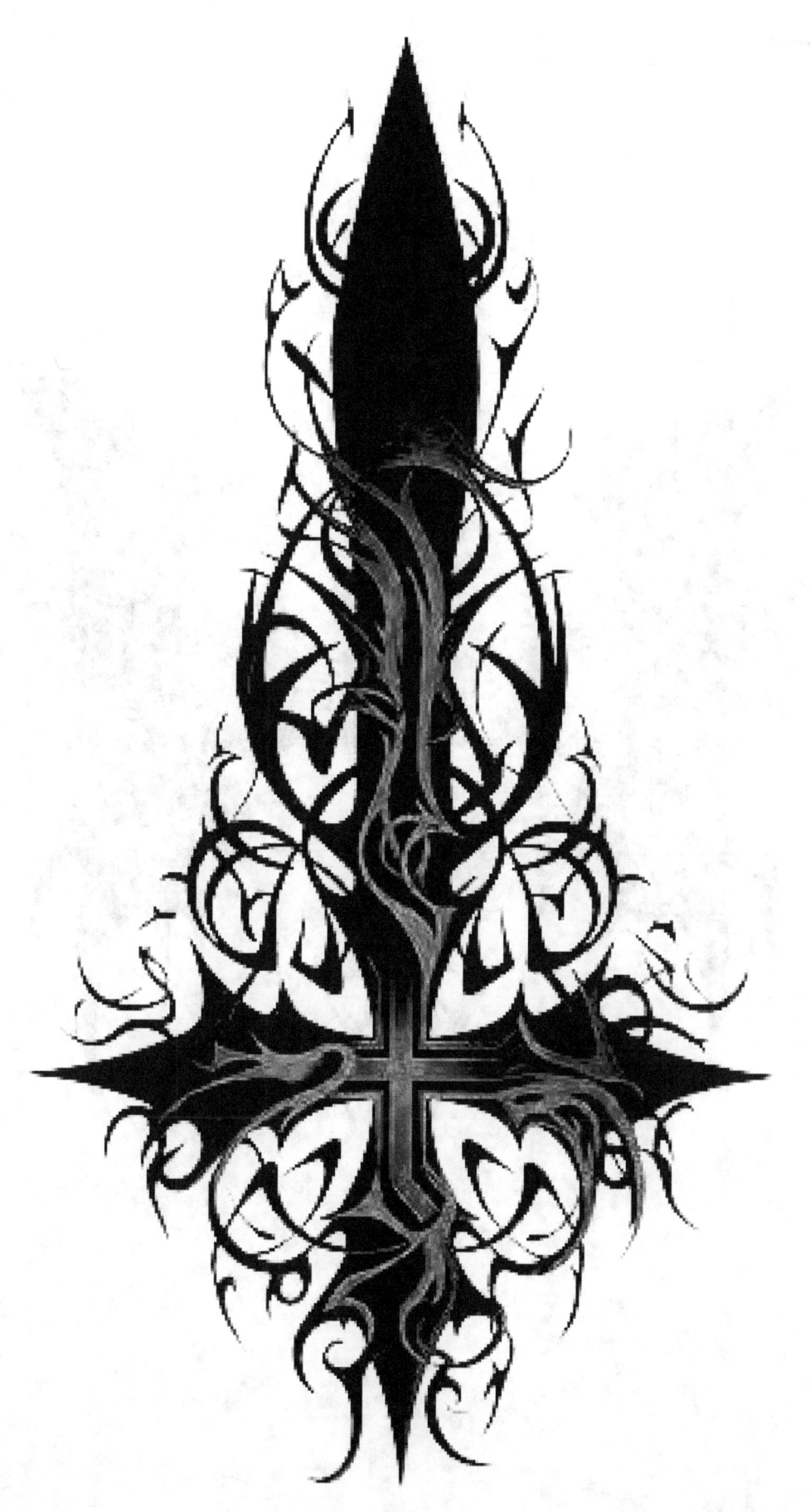

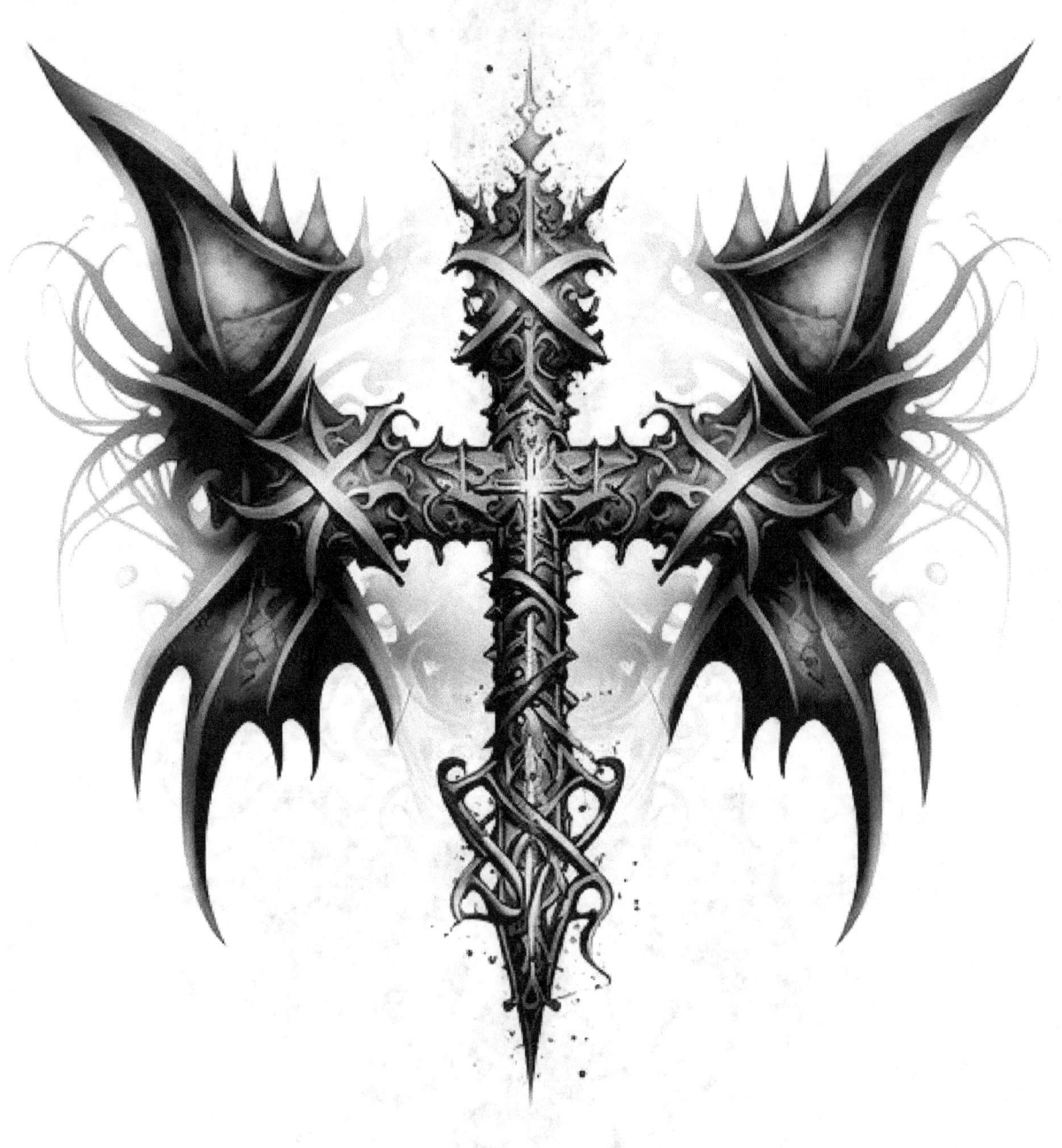

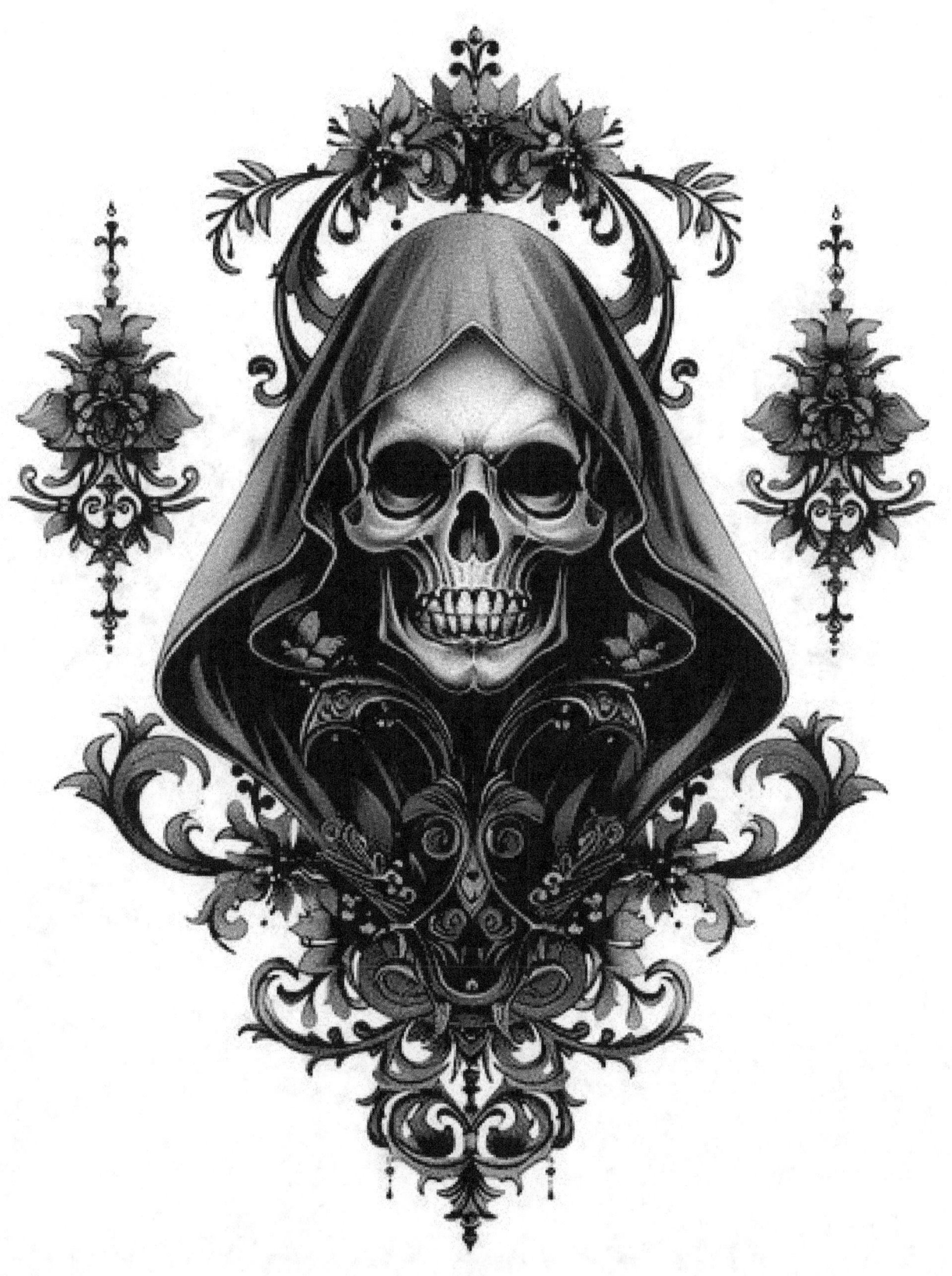

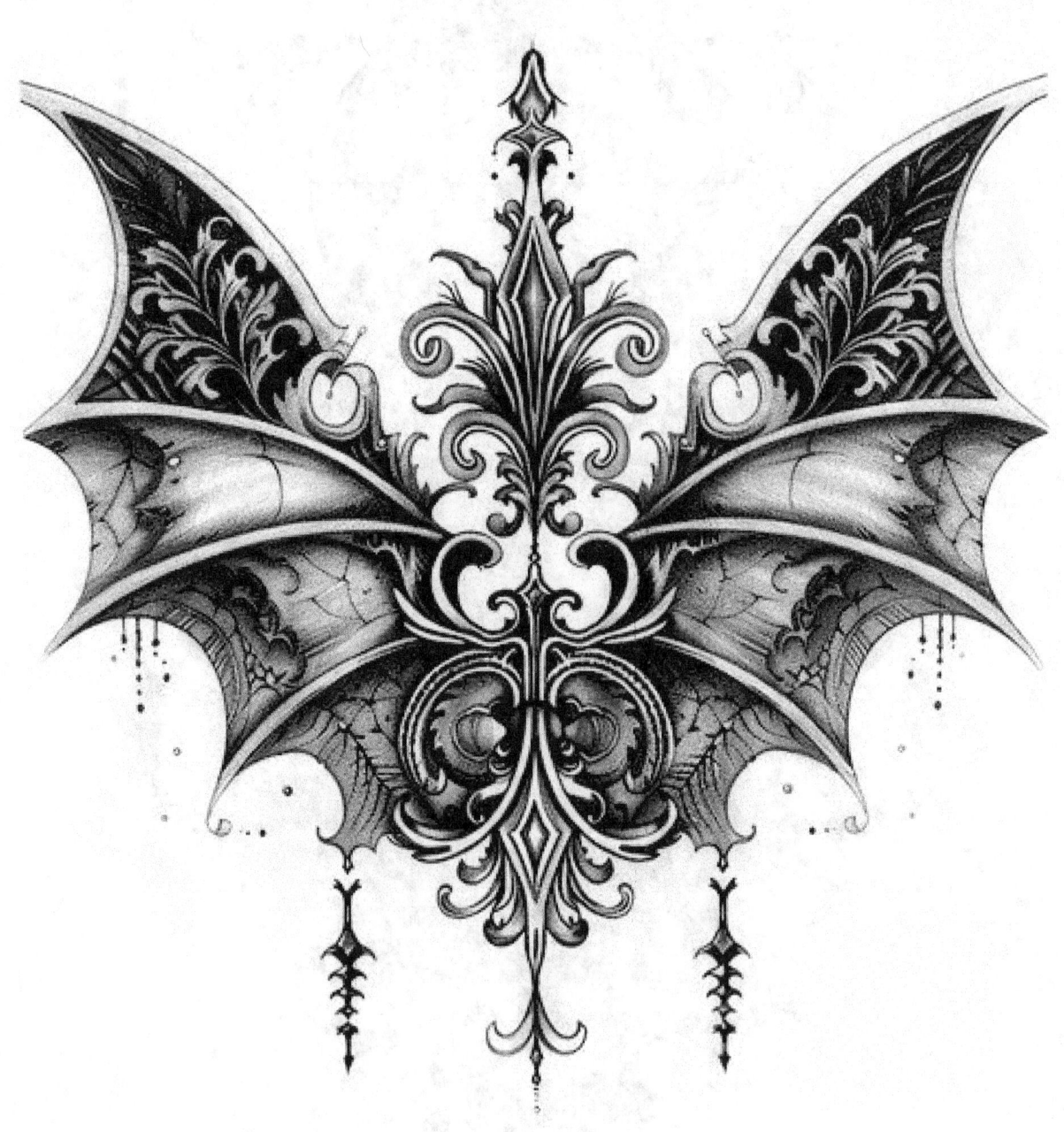

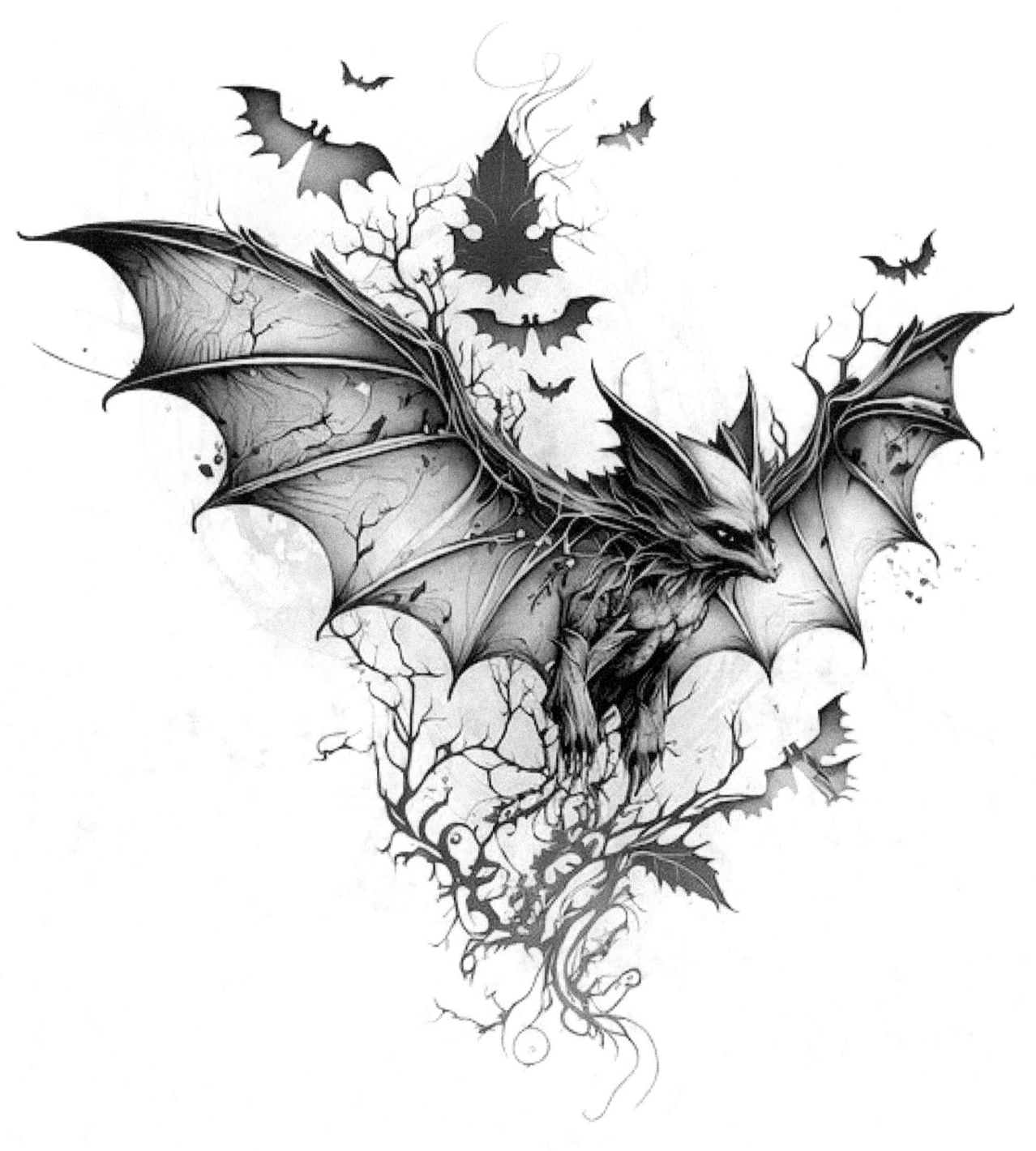

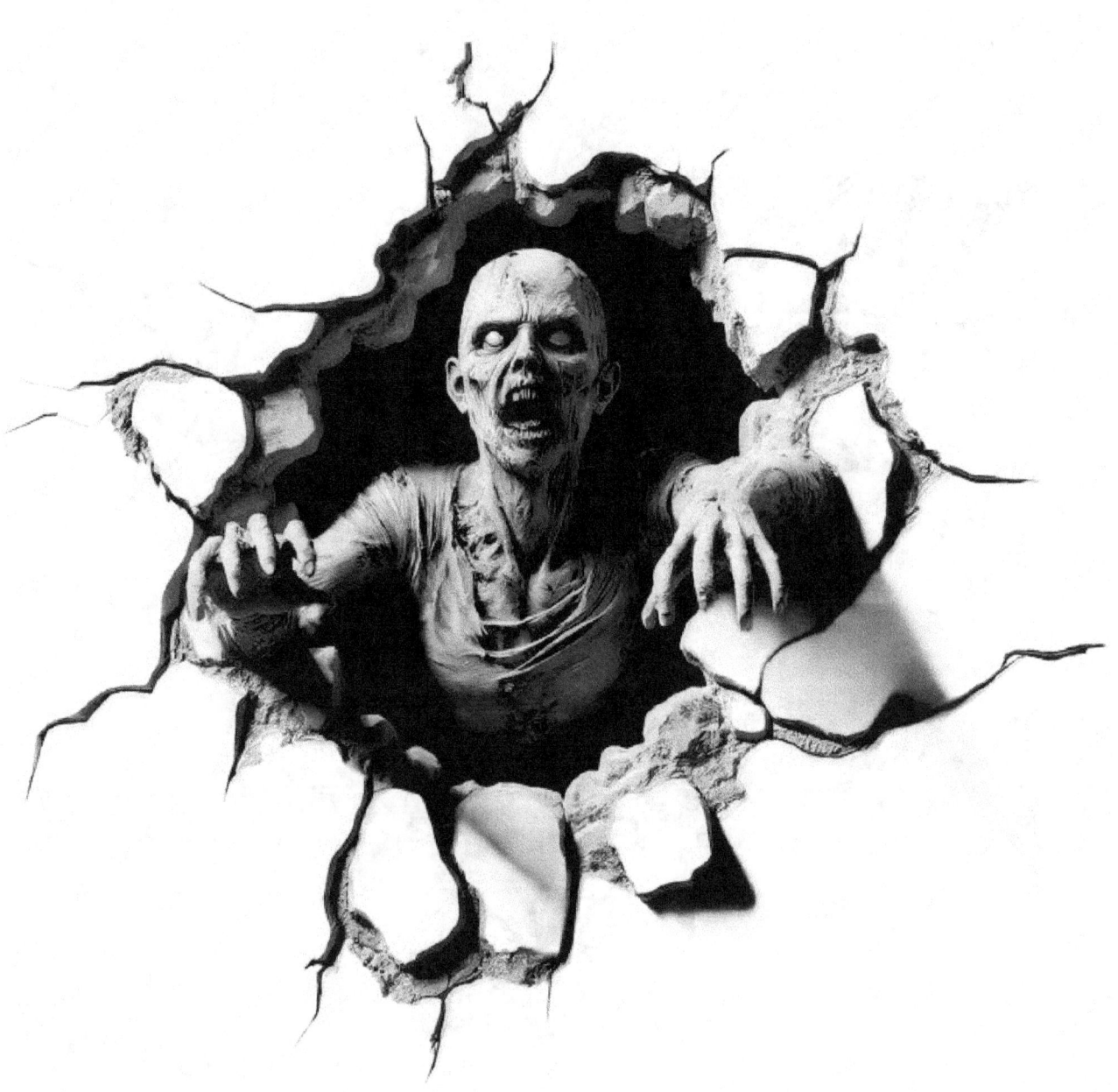

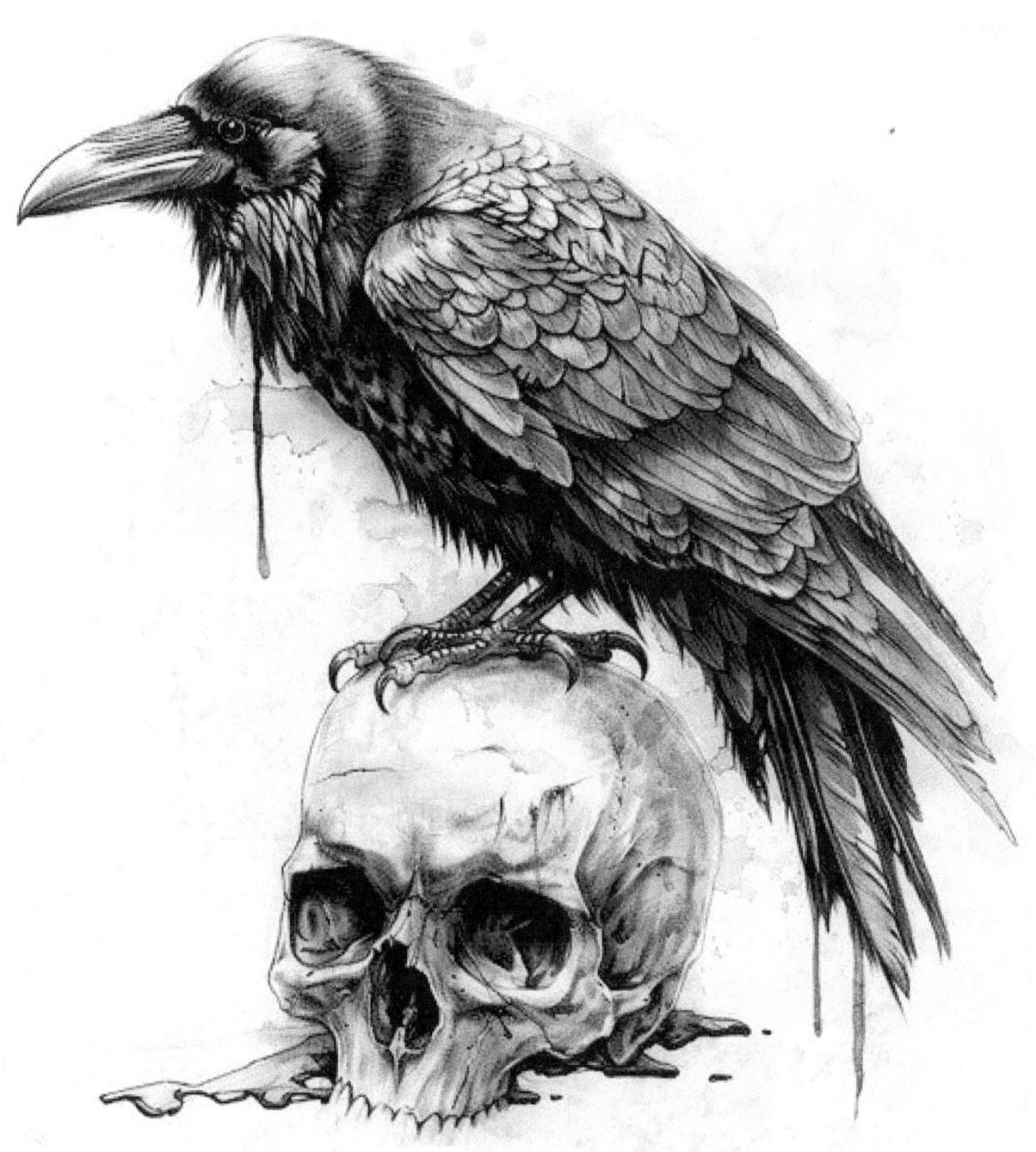

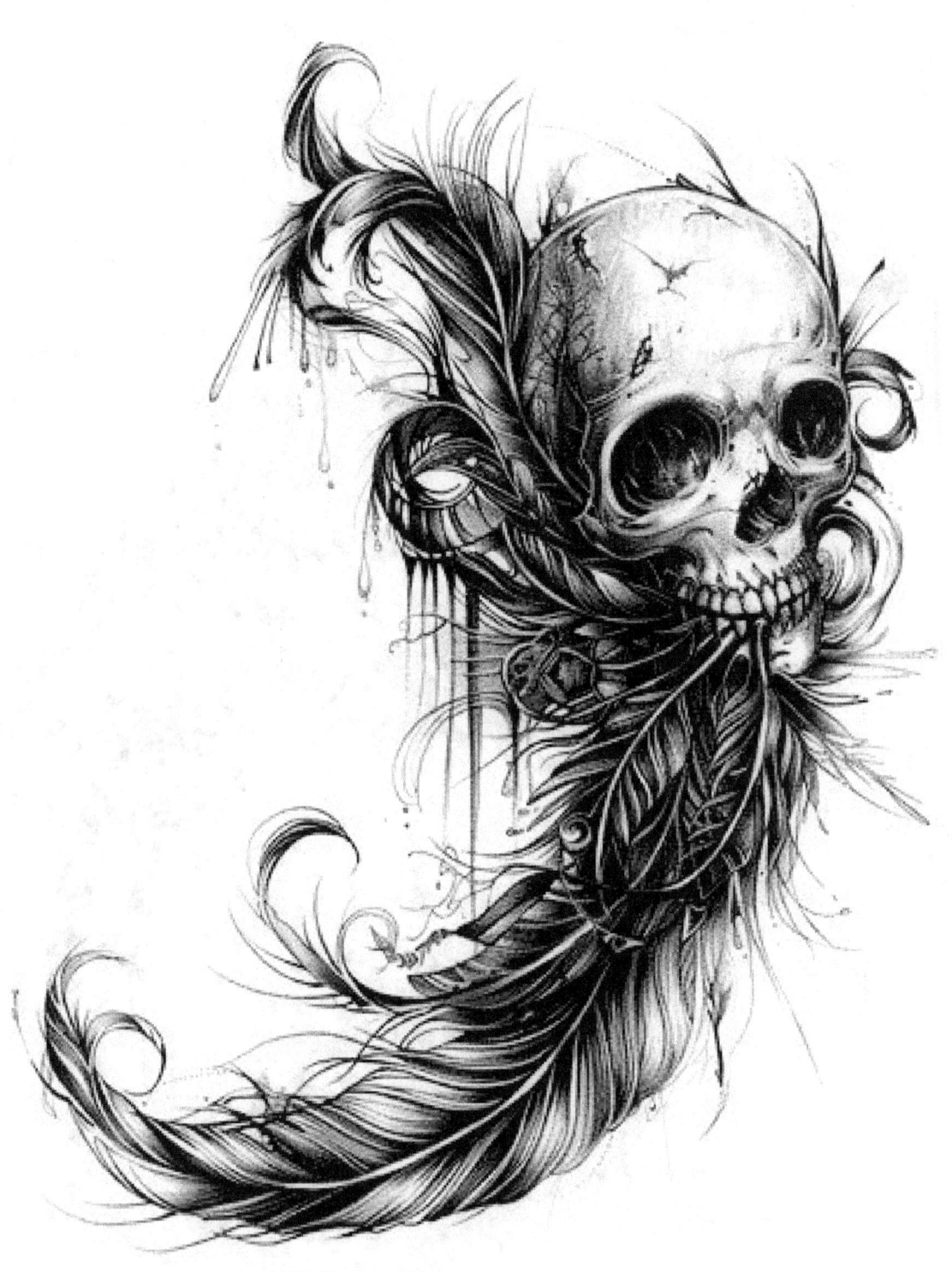

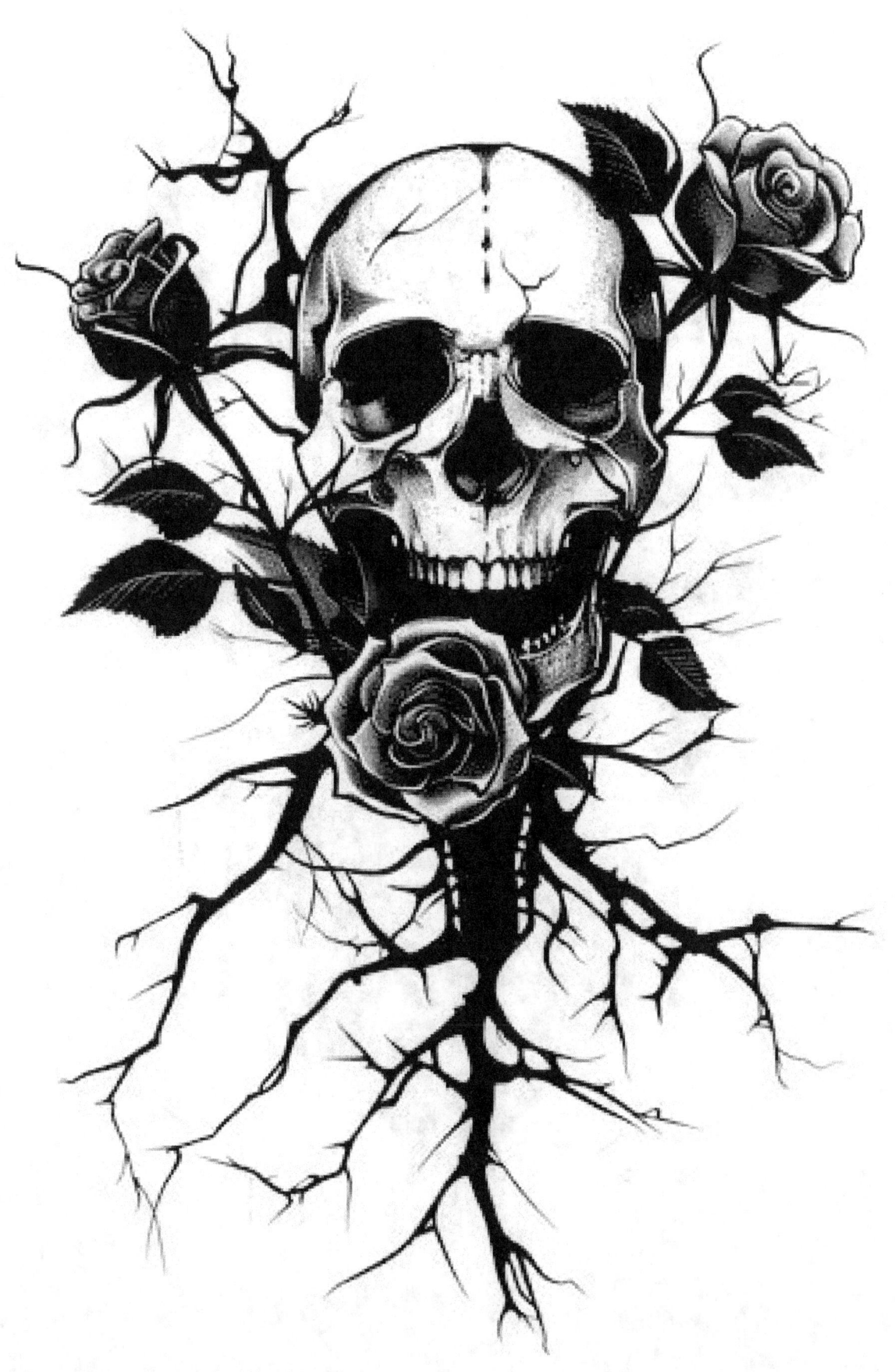

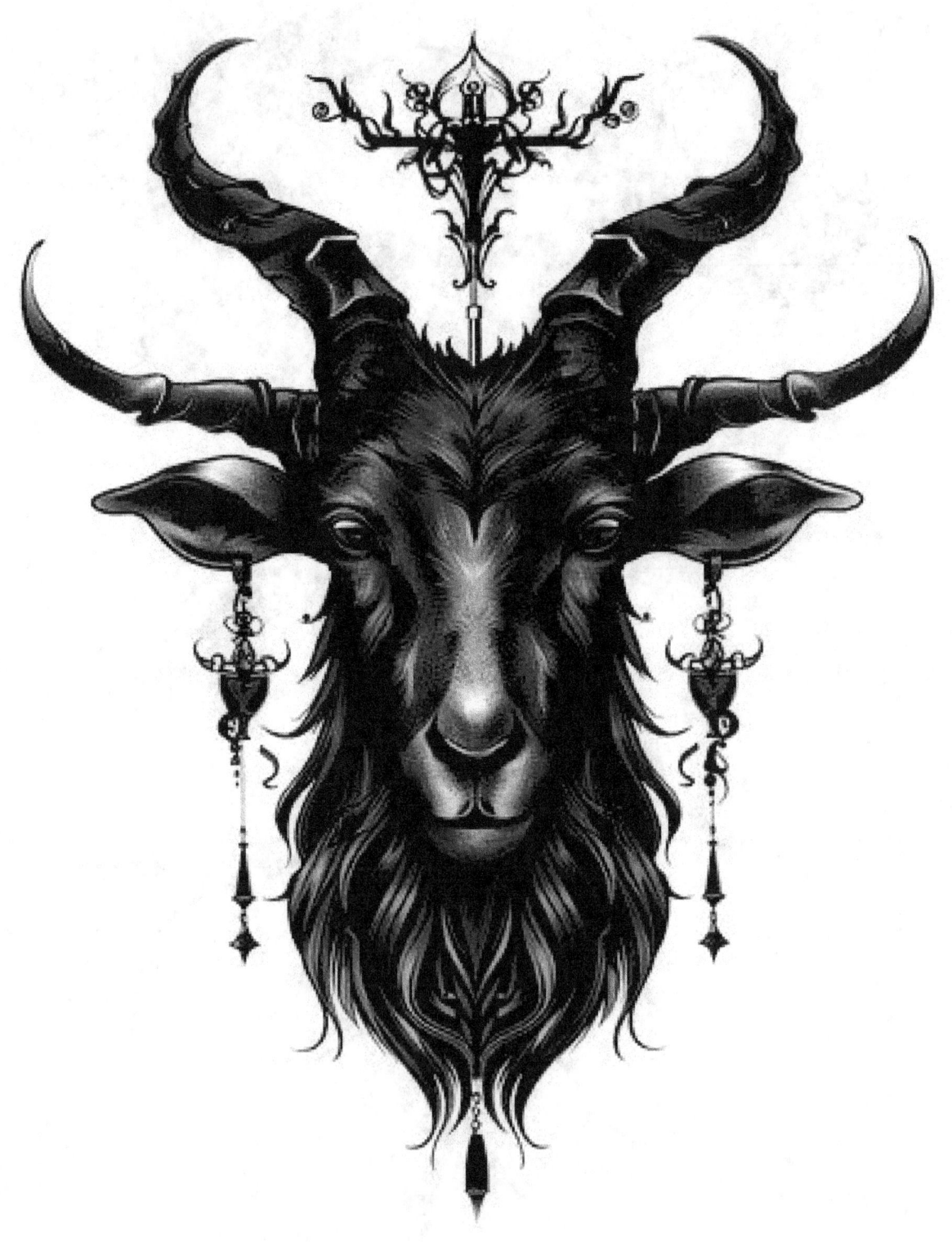

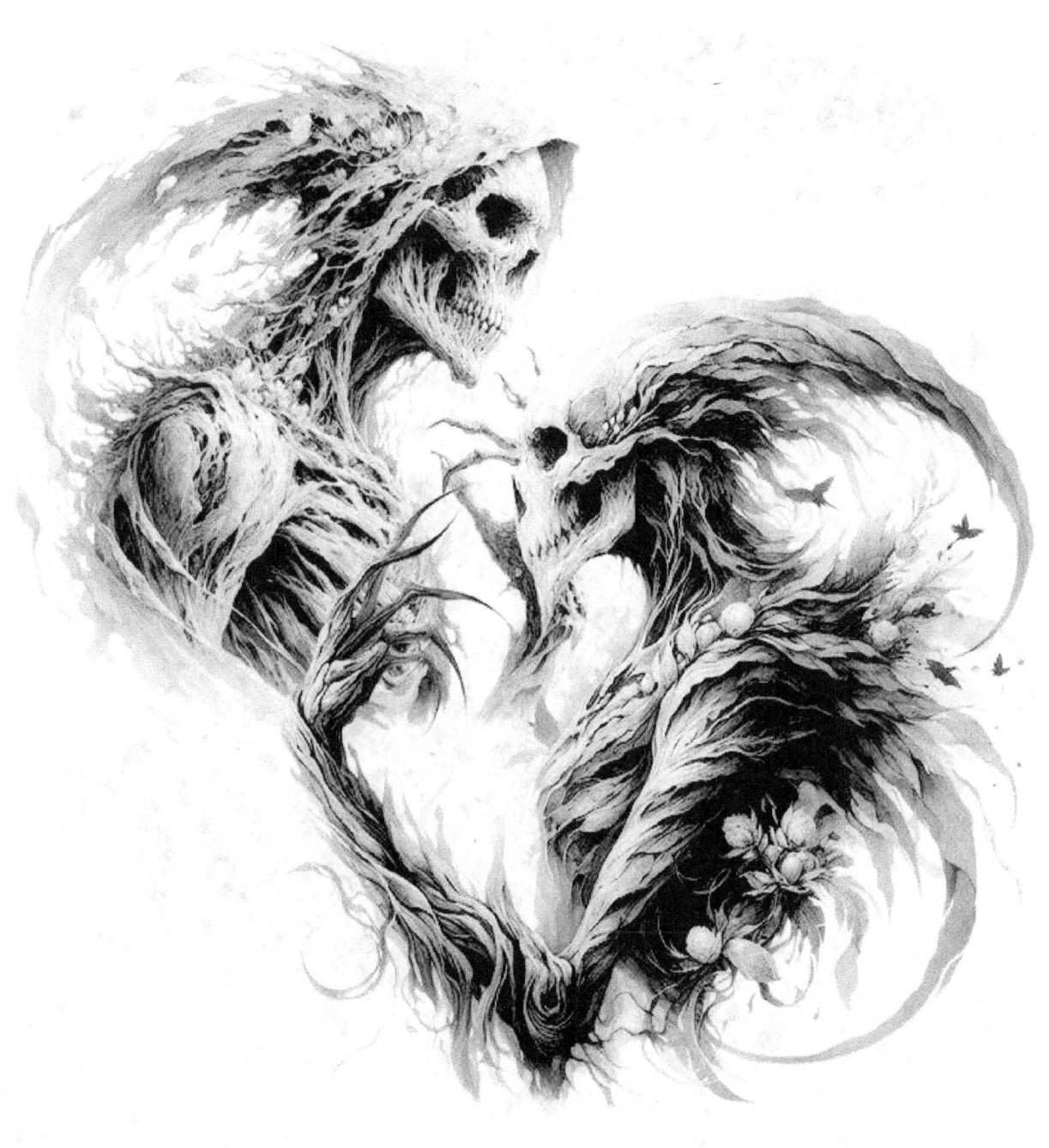

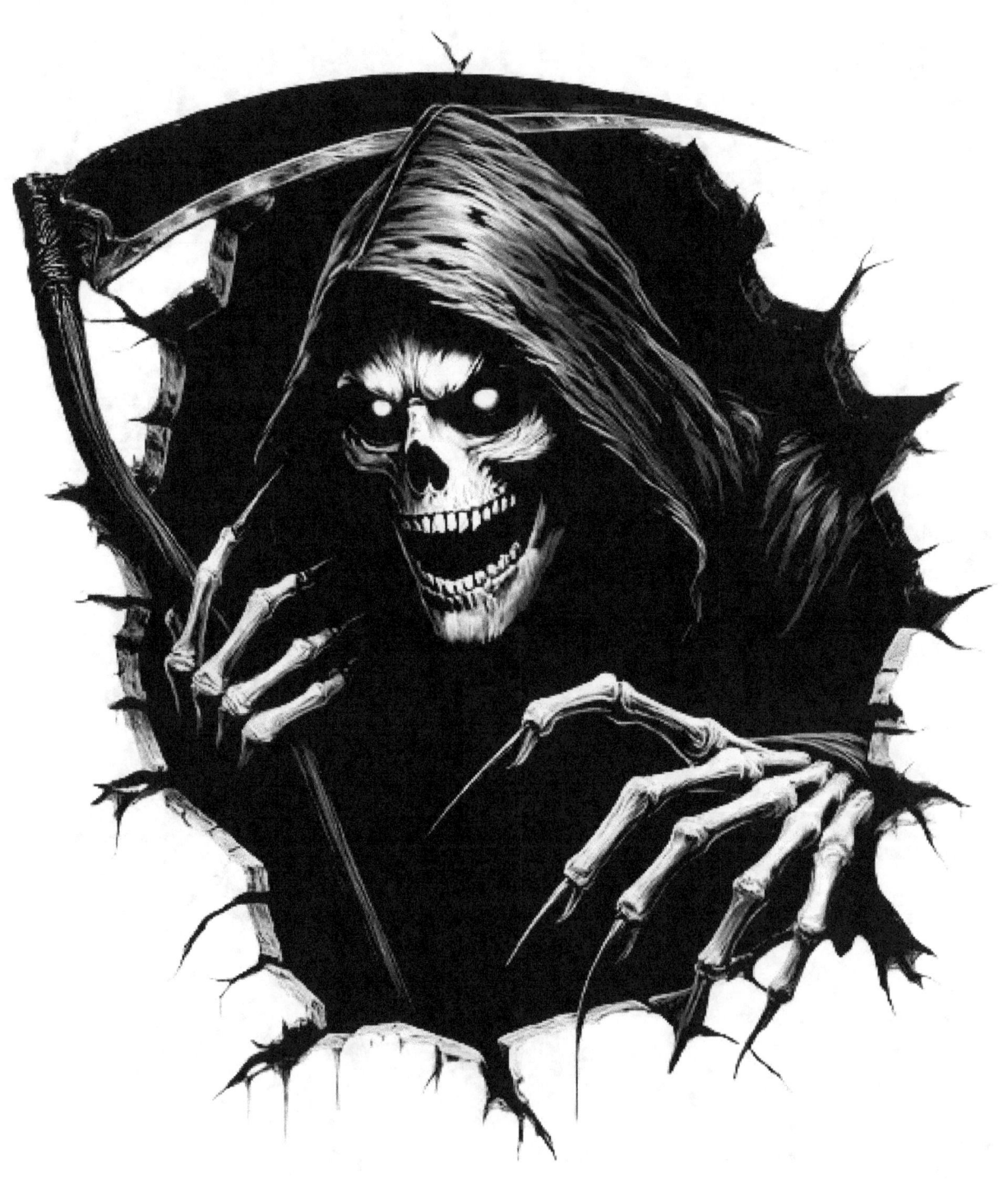

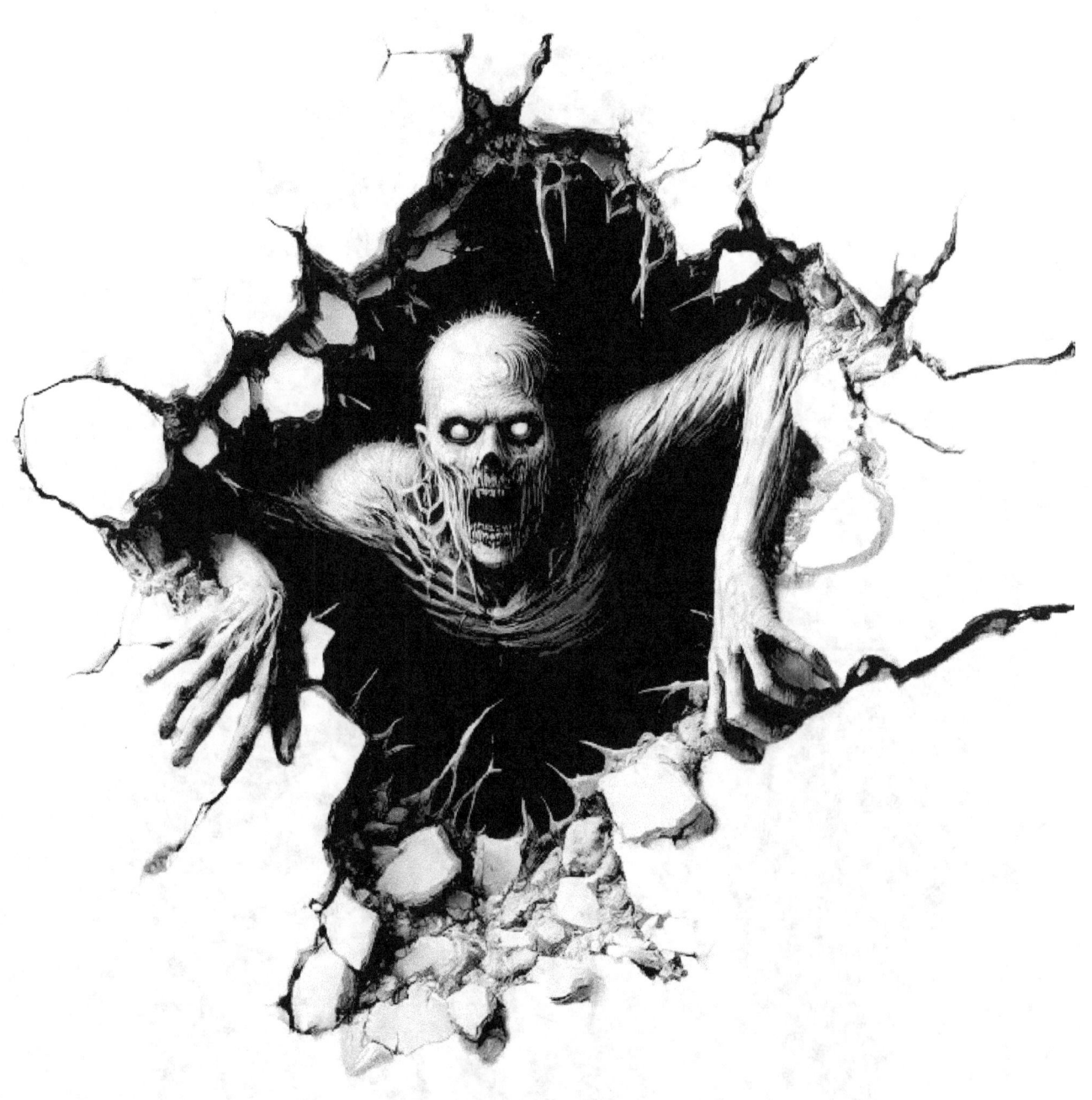

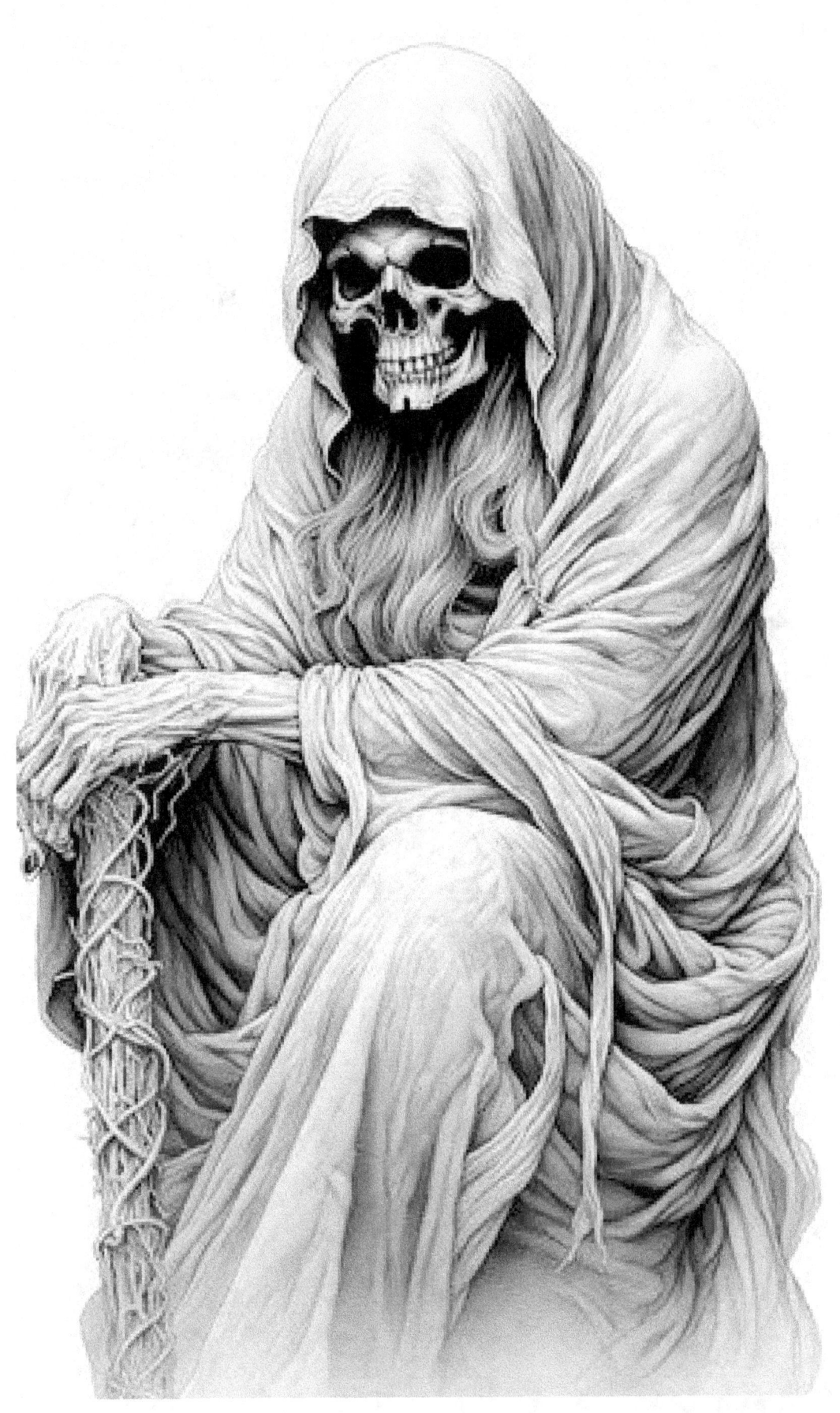

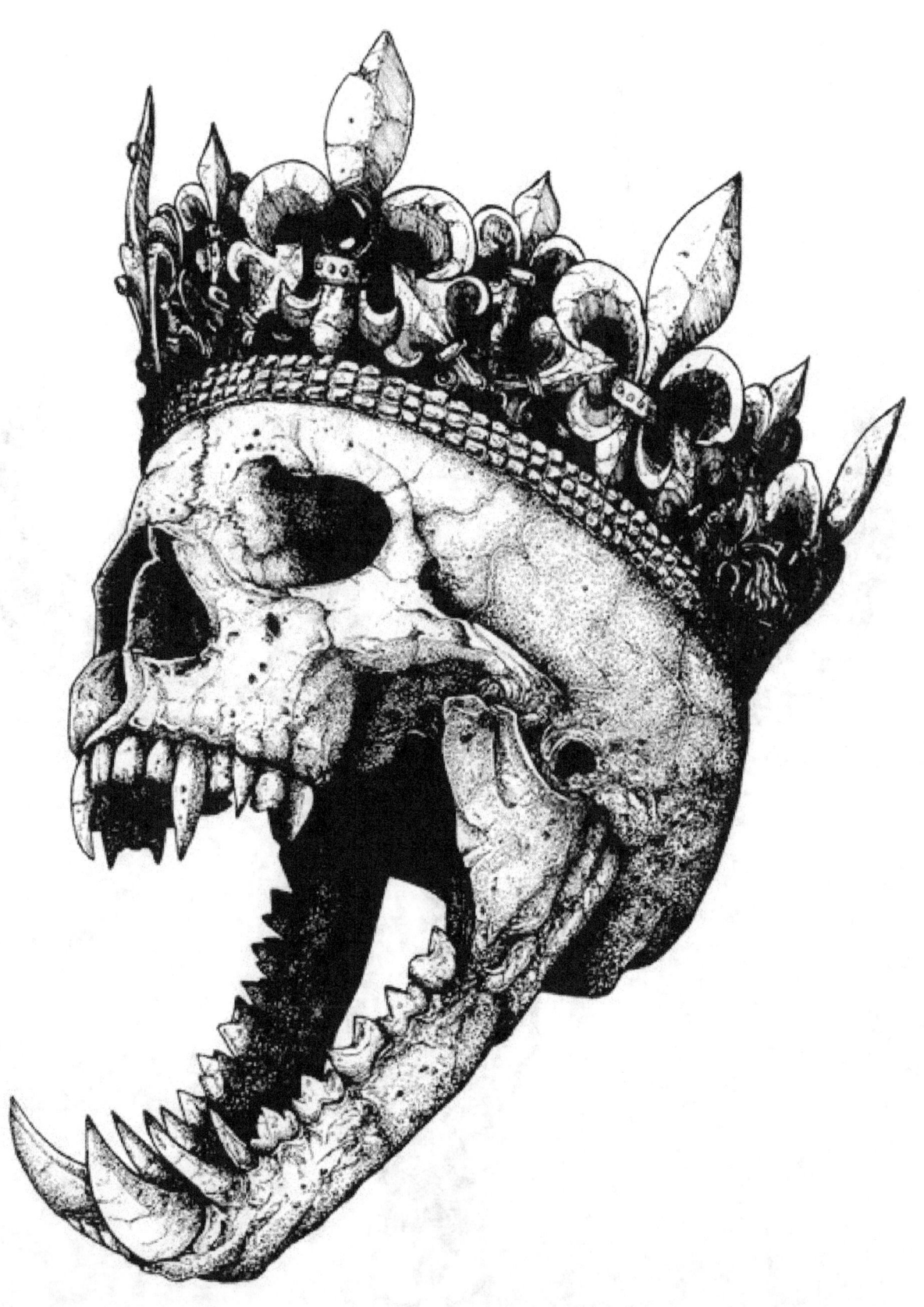

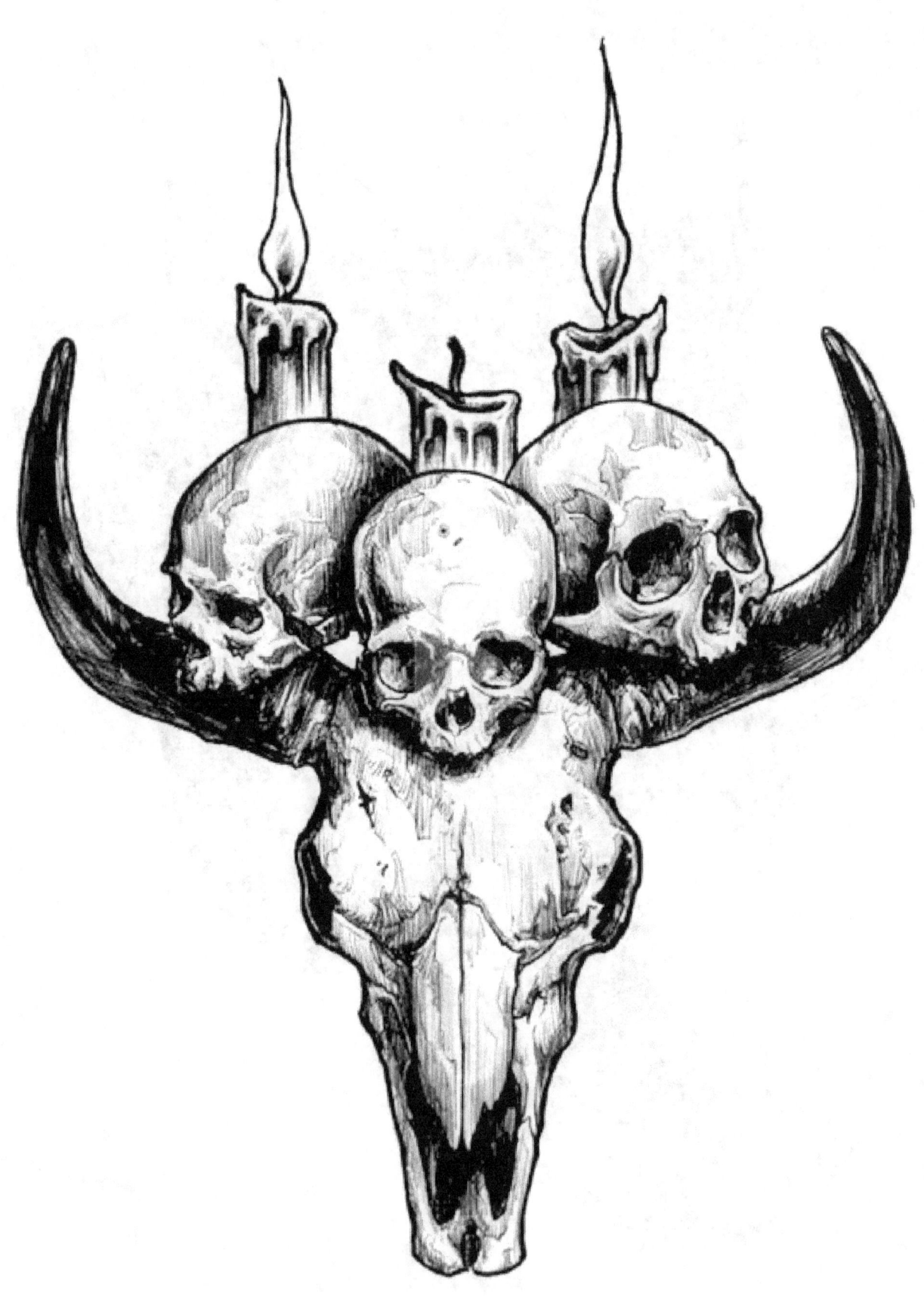

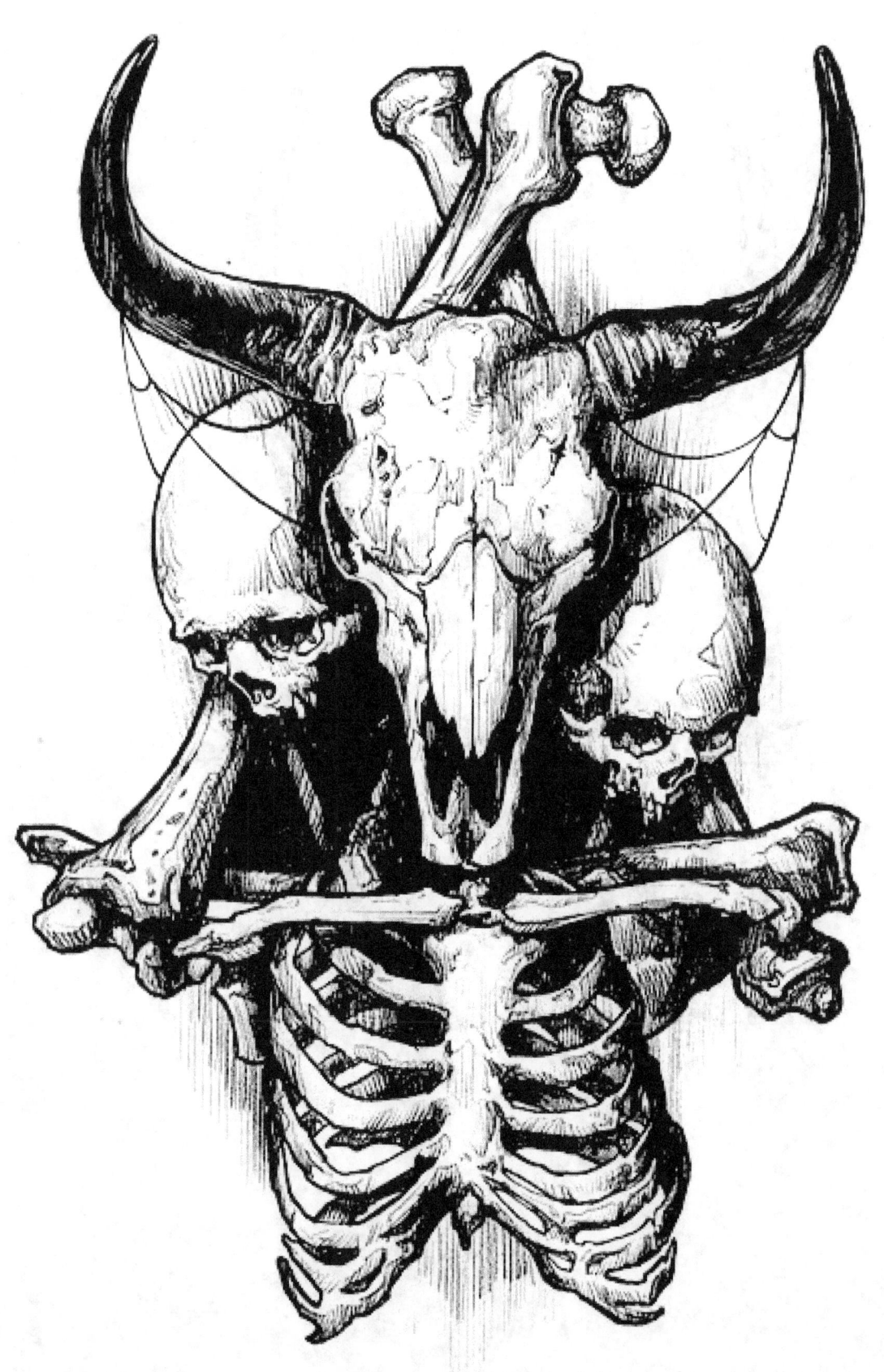

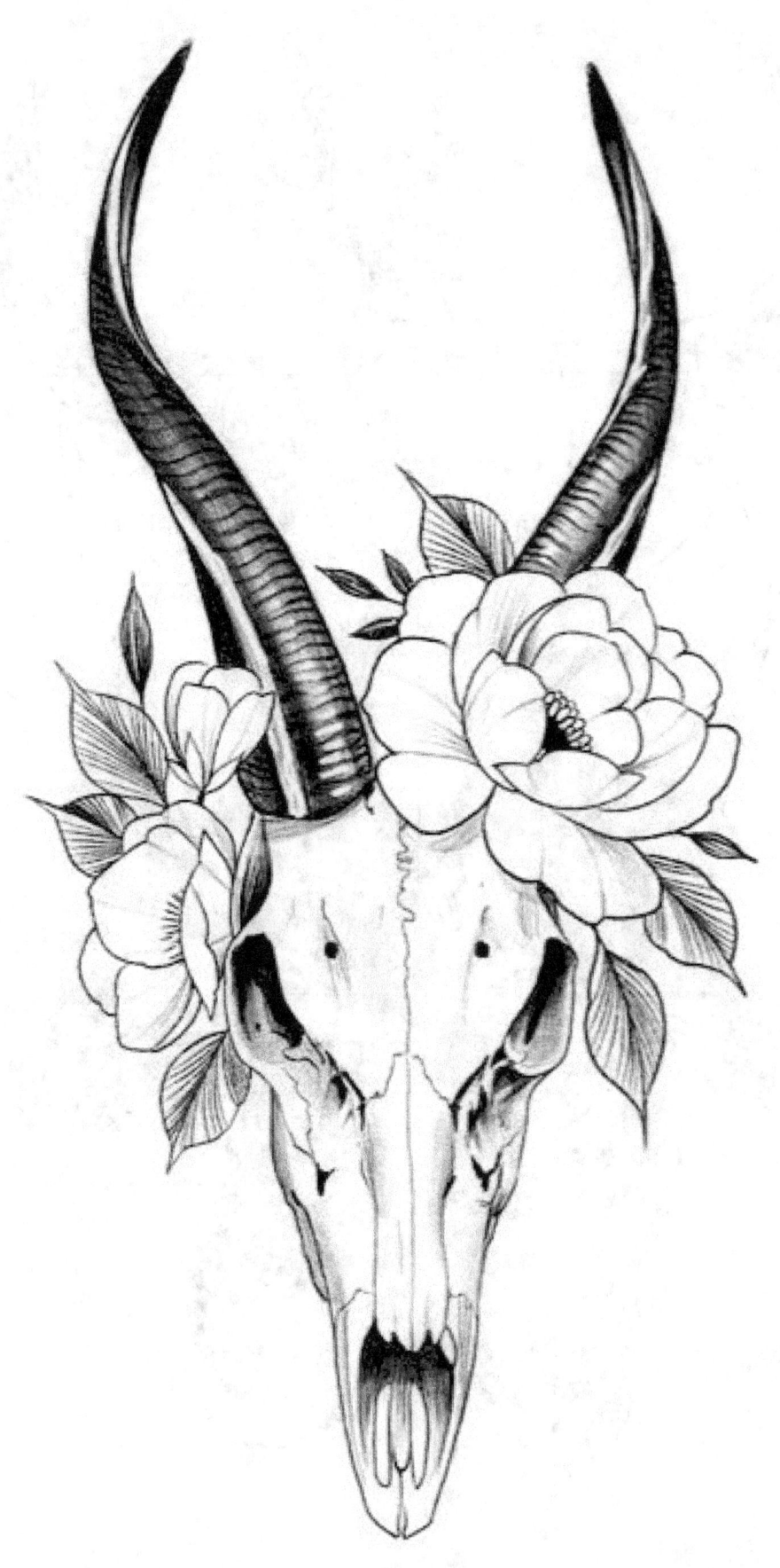

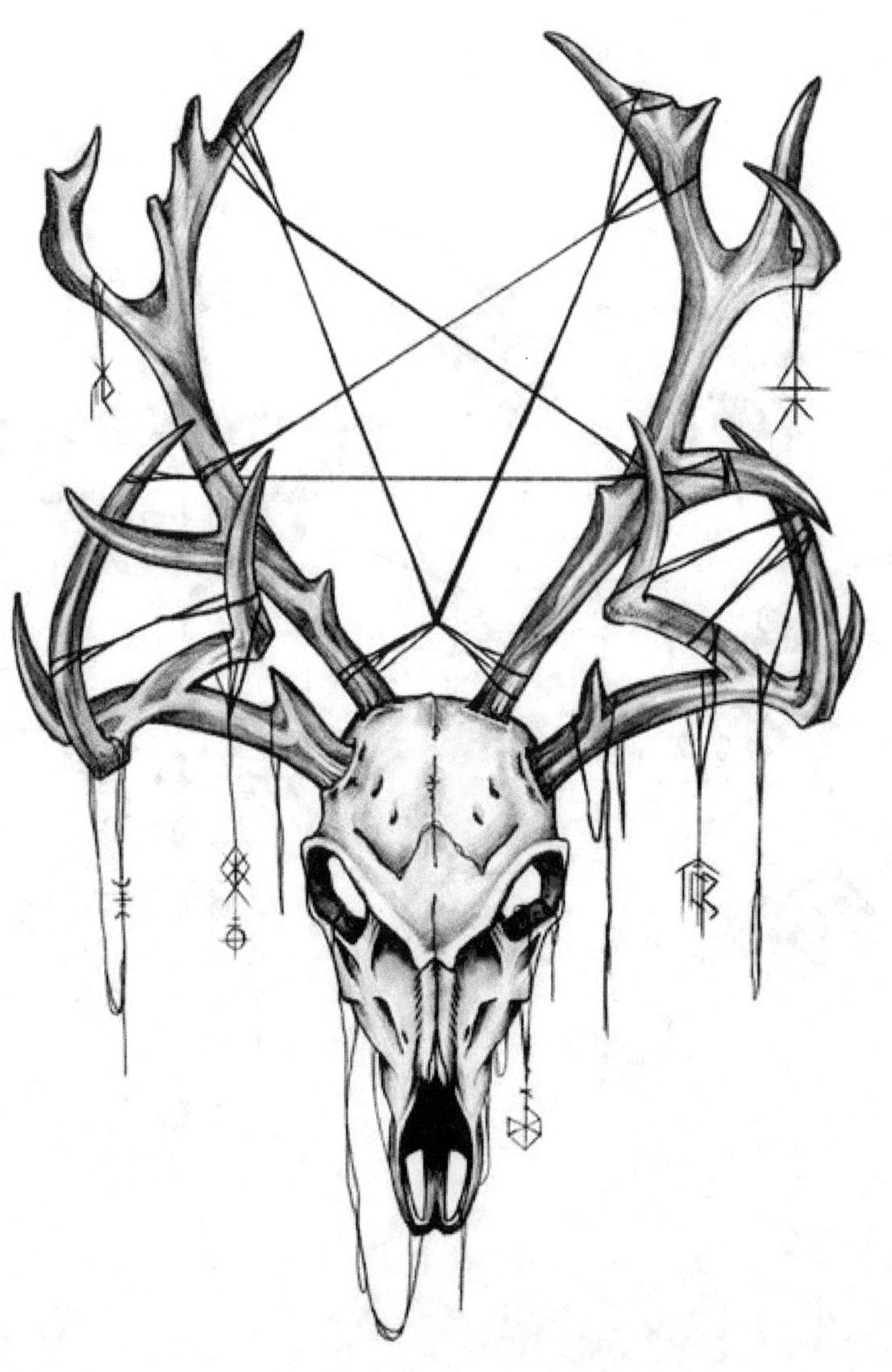

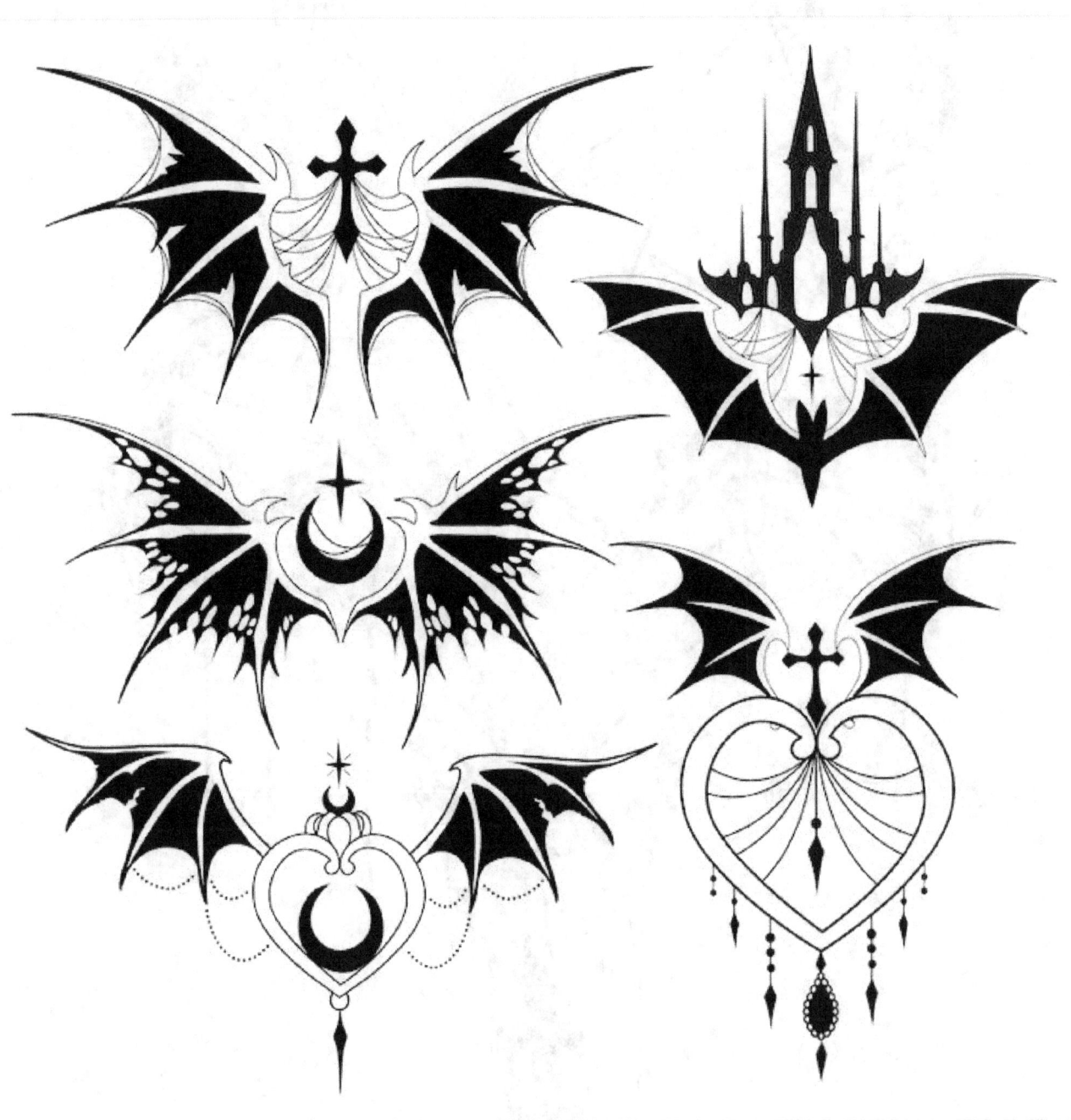

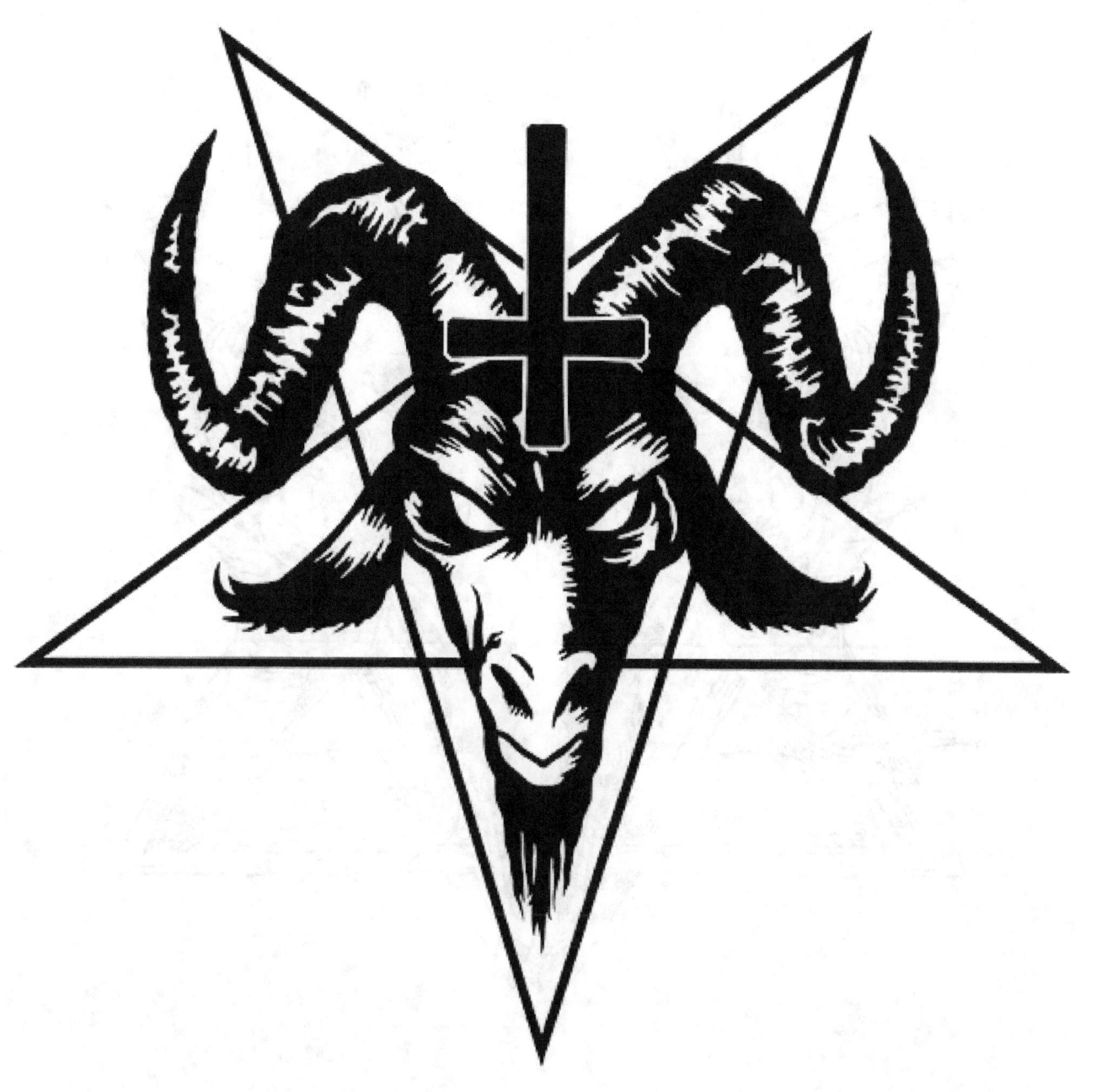

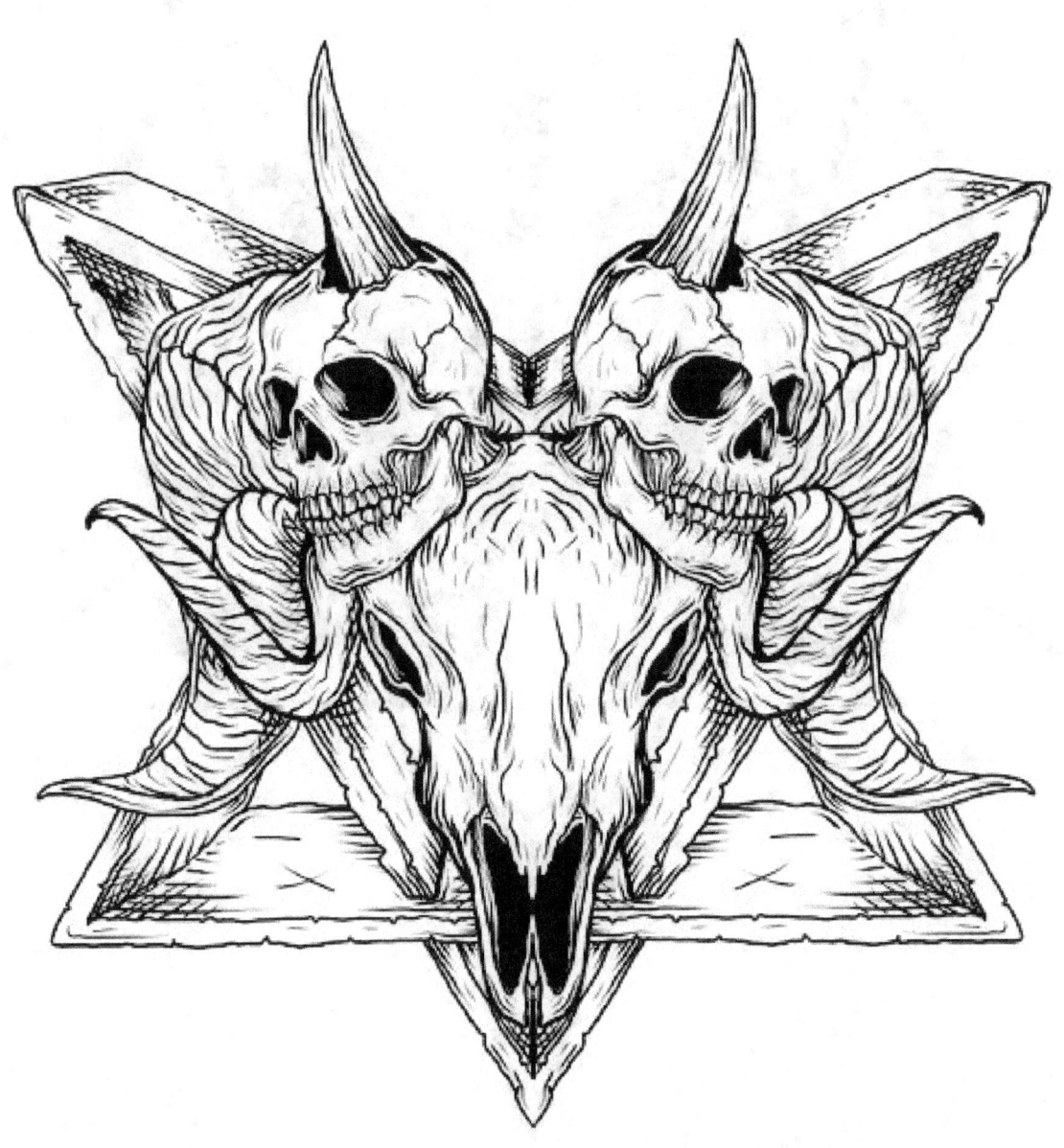

www.ingramcontent.com/pod-product-compliance
Lightning Source LLC
Chambersburg PA
CBHW082239220526

45479CB00005B/1282